Sharon Lockhart *Teatro Amazonas*

Museum Boijmans Van Beuningen Rotterdam
Kunsthalle Zürich
Kunstmuseum Wolfsburg
NAi Publishers Rotterdam

43600013

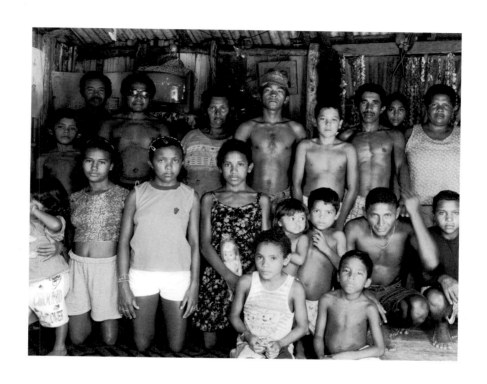

Foreword / Vorwort

The Museum Boijmans Van Beuningen Rotterdam, the Kunsthalle Zürich, and the Kunstmuseum Wolfsburg are very pleased to present this exhibition, which reflects our keen interest in and deep appreciation of Sharon Lockhart's exceptional work. In close collaboration with the artist, we have organized a presentation that focuses on a new series of works. Traveling and working with anthropologists, Lockhart shot this series recently at two locations in the Amazon region of Brazil. In her pictures of a fishing village on the island of Apeú-Salvador and of settlements of rubber tappers along the Rio Aripuanã, she investigates the complex relationships between photography and film and their changing status as documentary media. Complementing this project is a selection of earlier works that serve as reference points for the new photographs and make this exhibition the most complete survey of Lockhart's oeuvre to date.

In an interview, Jeff Wall once stated that 'We have to recognize the fact that motion pictures are only one possible outcome of cinematography.' Indeed, Lockhart uses the techniques of cinema not only to create still pictures, but highly original experimental films as well. We are therefore especially honored that she has made it possible for us to premiere her newest 'motion picture,' a 35mm film entitled *Teatro Amazonas*, in the exhibition. Shooting the film on location in the opera house in Manaus, the capital of the state of Amazonas, Lockhart cast an audience representative of neighborhoods in the city. Yet, resisting the temptation to have her cast perform their tasks of daily life for the camera, she dispensed with the standard practice of ethnographic documentary. This film continues Lockhart's investigation of the relationship between the photograph and the motion picture.

Organizing an exhibition and producing a film depend largely on the trust and support of many individuals and institutions. Our thanks above all to Sharon Lockhart for her intensive involvement in the realization of the exhibition, the film, and the catalogue. Karel Schampers, who played a key role in the organization of the entire project, deserves special mention. We are equally grateful to the galleries neugerriemschneider, Berlin; Blum & Poe, Santa Monica; and Friedrich Petzel, New York for their invaluable advice and assistance. In addition, we gratefully acknowledge the support of the lenders

Das Museum Boijmans Van Beuningen Rotterdam, die Kunsthalle Zürich und das Kunstmuseum Wolfsburg freuen sich sehr, diese Ausstellung zu zeigen, die unser großes Interesse an Sharon Lockharts künstlerischer Arbeit und unsere Wertschätzung ihres außergewöhnlichen Werkes wiederspiegelt. In enger Absprache mit Sharon Lockhart haben wir uns darauf geeinigt, unser Augenmerk vor allem auf eine neue Serie von Werken zu richten. Auf gemeinsamen Reisen und Expeditionen mit Anthropologen hat Lockhart diese Serie erst unlängst an zwei verschiedenen Plätzen im brasilianischen Amazonas-Gebiet fotografiert. Mit ihren Bildern eines Fischerdorfes auf der Insel Apeú-Salvador und von Kautschukzapfer-Siedlungen am Rio Aripuanã erkundet sie die komplexe Beziehung zwischen Fotografie und Film und ihren sich wandelnden Status als Medien der Dokumentation. Eine Auswahl früherer Arbeiten gestattet es dem Betrachter ferner, Vergleiche anzustellen. Damit bietet diese Ausstellung den derzeit umfassendsten Überblick über Sharon Lockharts bisherige Arbeit.

In einem Interview hat Jeff Wall einmal gesagt: 'Wir müssen die Tatsache zur Kenntnis nehmen, dass bewegte Filmbilder lediglich ein mögliches Ergebnis der Kinematographie sind.' Tatsächlich schafft Lockhart mit Hilfe der Techniken des Kinos nicht allein 'Standfotos', sondern zudem außerordentlich originelle Experimentalfilme. Gerade deshalb sind wir besonders dankbar, dass die Künstlerin es uns möglich macht, ihren 35mm-Film *Teatro Amazonas* in der Ausstellung uraufzuführen. Für die Dreharbeiten im Opernhaus von Manaus, der Hauptstadt des Staates Amazonas, hat Lockhart im Zuschauerraum ein Publikum versammelt, das für die verschiedenen Viertel der Stadt repräsentativ ist. Sie widerstand also der Versuchung, ihre 'Darsteller' vor der Kamera ihr Alltagsleben inszenieren zu lassen, wie es der übliche ethnographische Dokumentarfilm gerne tut. Mit diesem Film setzt Lockhart ihre Erkundung der Beziehung zwischen Fotografie und Film.

Wer eine Ausstellung organisieren oder einen Film produzieren möchte, ist ganz entschieden auf das Vertrauen und die Mithilfe zahlreicher Personen und Institutionen angewiesen. Wir möchten daher vor allem Sharon Lockhart für ihre engagierte Unterstützung bei der Realisierung der Ausstellung, des Films und des Katalogs danken. Speziell erwähnen möchten wir zudem Karel Schampers, der bei der

who were prepared to entrust their photographs to us for such a lengthy period of time. Special thanks also go to Gracia Lebbink for her meticulous care in designing the catalogue, and to Timothy Martin and Ivone Margulies for their enlightening catalogue essays. Finally, the exhibition was immeasurably enhanced by the excellent collaborative relationship that developed among the Museum Boijmans Van Beuningen Rotterdam, the Kunsthalle Zürich, and the Kunstmuseum Wolfsburg.

Chris Dercon
Museum Boijmans Van Beuningen Rotterdam

Bernhard Bürgi
Kunsthalle Zürich

Gijs van Tuyl
Kunstmuseum Wolfsburg

Organisation des gesamten Projektes eine Schlüsselrolle gespielt hat. Zu Dank verpflichtet sind die Organisatoren aber auch den Galerien neugerriemschneider, Berlin; Blum & Poe, Santa Monica; und Friedrich Petzel, New York, für ihren wertvollen Rat und für ihre Unterstützung. Weiter möchten wir den Leihgebern danken, die bereit waren, uns ihre Fotografien für einen so langen Zeitraum anzuvertrauen. Unser besonderer Dank gilt überdies Gracia Lebbink für ihre sorgfältige Arbeit bei der Gestaltung des Katalogs sowie Timothy Martin und Ivone Margulies für ihre erhellenden Katalog-Beiträge. Zum Schluss möchten wir noch auf die exzellente Zusammenarbeit zwischen dem Museum Boijmans Van Beuningen Rotterdam, der Kunsthalle Zürich und dem Kunstmuseum Wolfsburg verweisen.

Chris Dercon
Museum Boijmans Van Beuningen Rotterdam

Bernhard Bürgi
Kunsthalle Zürich

Gijs van Tuyl
Kunstmuseum Wolfsburg

Contents / Inhalt

Documentary Theater /
Dokumentar - Theater

Timothy Martin

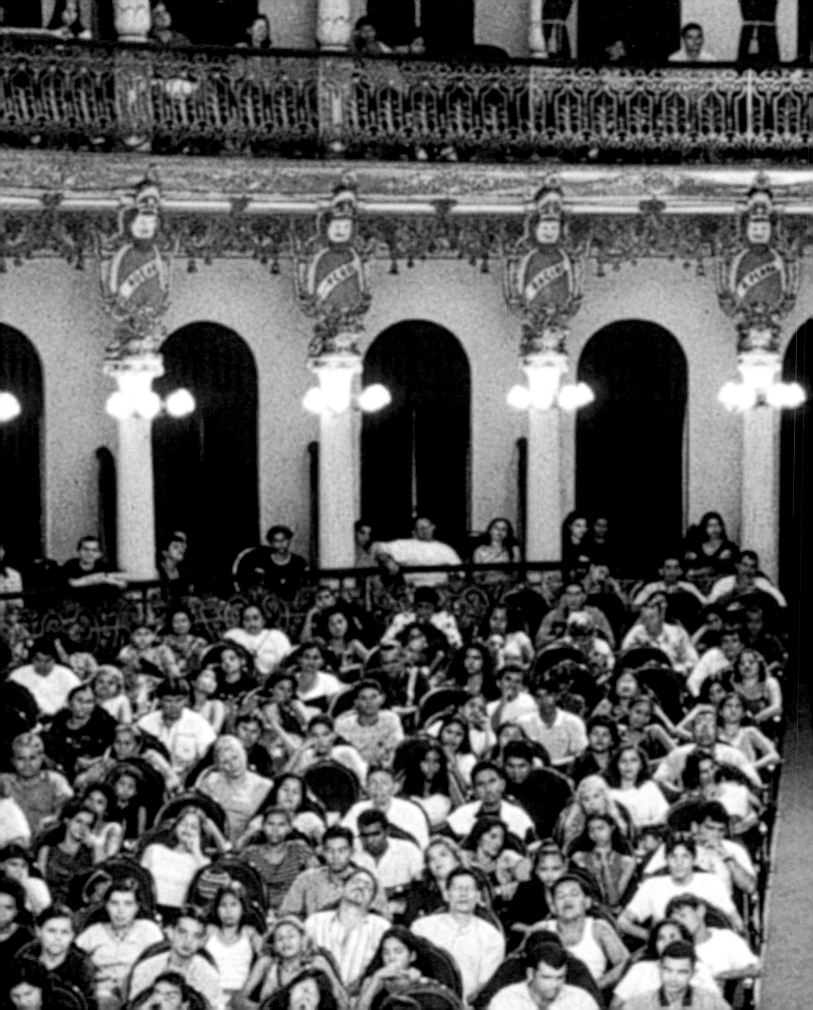

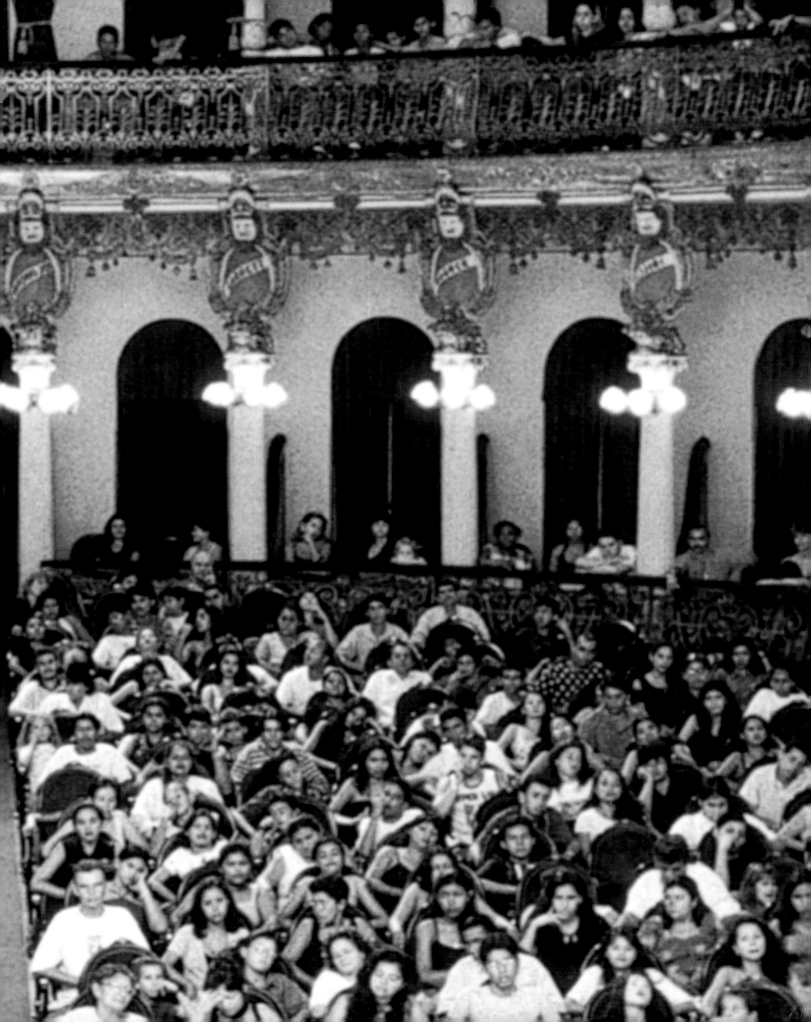

Those familiar with Sharon Lockhart's previous photographic work may find the images in this volume somewhat surprising, and their point(s) of view elusive, puzzling. Of course, we have come to expect a certain degree of inscrutability in Lockhart's practice, owing primarily to the tension between her near-constant self-reinvention and hybridization and the impressive succession of self-culminating 'high forms' that appear to result from it. That is, her individual works, while frequently drawing on a complex of historical forms, are often so engaging and affective in themselves, and so fully distilled, as to eclipse questions of their overall schema or strategy. And Lockhart is generally loathe to dilute an achievement of dramatic effect with protestations of its nominal aims or ultimate frame of reference. If one were to identify the changeability of her practice as an itinerant style of appropriation, as some have, one might view this eclipse as a transgression, for appropriation is supposed at all times to *realize* its historical positioning, ideally within and through the power of its effects. The blind spot of this sort of formulation, however, is its intolerance of the creature of hybridity, which is never fully reducible to its parentage (quotation) and is always in some way out of control. Without excusing (or imputing) any neglect of historical conscience, I would suggest that Lockhart may be described better as a 'shape-shifter' than an appropriator, a distinction that rests on putting adequate emphasis on her least rationalizable processes – which I will attempt with no further reference to science fiction, though a different sort of 'science fiction' does indeed play a part in the derivation of the images in this volume. Inscrutability in Lockhart's practice, because it arises from a co-presence of deceptively simple appearances and overtly complex artistic means, is perforce an integral part of her work's *genius loci*. It is not an obstacle that must be overcome in order to comprehend what she is doing; it is the thing itself to be comprehended and hence confronted in any serious consideration of her work to date.

Lockhart's Brazilian project, which encompasses the photograph series reproduced in this volume and the film, *Teatro Amazonas* (1999), provides what is perhaps the most exemplary demonstration of the extent to which her practice can shift its frame of reference, its shape, within the boundaries of a given body of work. If the project's overall point of view remains elusive and puzzling, it is because it is multiple, adaptive, and opportunistic. Its various

Teatro Amazonas, 1999 (film still/Standfoto)
35mm film
38 min./Min.
color-sound/Farb-Tonfilm
courtesy Blum & Poe, Santa Monica

Wenn man Sharon Lockharts früheres fotografisches Werk kennt, mögen die Bilder in diesem Buch überraschend wirken und ihre Sichtweise(n) vielleicht ein wenig verwirrend oder schwer nachvollziehbar erscheinen. Natürlich erwartet man bei Lockhart eine gewisse Unergründlichkeit, die vor allem auf der Spannung zwischen einer fast ständigen Neubestimmung des eigenen Standorts sowie Überkreuzungen von Genres einerseits und der eindrücklichen Folge von sich steigernder 'Hoch-Formen' andererseits beruht, welche sich daraus zu ergeben scheinen. Während einzelne ihrer Arbeiten sich oft auf einen Komplex historischer Formen beziehen, sind sie zugleich in sich so faszinierend und gefühlsgeladen, so konzentriert, dass die Frage nach ihrer Systematik oder Strategie in den Hintergrund tritt. Außerdem hat Lockhart eine Abneigung dagegen, einen dramatischen Effekt durch Erläuterungen zum angestrebten Ziel oder zum Bezugsrahmen wieder zu verwässern. Wenn manche die Wandelbarkeit ihrer künstlerischen Praxis für eine flexible Form der Aneignung halten, dann kann man in der Unergründlichkeit vielleicht eine Art von Überschreitung erkennen. Denn Aneignung muss ihren historischen Ort immer im Auge behalten, idealerweise mit und in ihrer eigenen Wirkungsweise. Bei dieser Vorgehensweise liegt der blinde Punkt allerdings darin, dass die hybride Form ein heikles Gebilde ist, das sich niemals ganz auf seine Herkunft (als Quelle des Zitats) reduzieren lässt und bis zu einem gewissen Grad unkontrollierbar bleibt. Ohne die Vernachlässigung von historischem Bewusstsein entschuldigen (oder ankreiden) zu wollen, würde ich es doch vorziehen, Lockhart eher als Form-Verschieber denn als Aneigner zu betrachten, eine Unterscheidung, die ihre rational kaum fassbaren Prozesse gleichermaßen ins Kalkül zieht. Dabei will ich nicht weiter auf den Science-Fiction-Charakter eingehen, wenngleich eine andere Art von 'Science Fiction' bei der Herkunft der Bilder in diesem Buch durchaus eine Rolle spielt. Die Unergründlichkeit ergibt sich in Lockharts Praxis aus dem täuschend einfachen Erscheinungsbild einerseits und den überaus vielschichtigen künstlerischen Mitteln andererseits; sie ist logischerweise ein integraler Bestandteil des *genius loci* ihres Werks. Keineswegs handelt es sich dabei um ein Hindernis, das überwunden werden muss, um ihre Arbeit zu verstehen. Vielmehr ist es die Sache an sich, die es zu verstehen gilt, und mit der man sich daher auch in jeder ernsthaften Betrachtung ihres Werks auseinander setzen muss.

photographic and filmic moments drift between poles of apparent articulation, concealment, and deferral with respect to their subject(s), to the degree that the viewer must at times doubt whether the apparent subject is indeed the subject intended. This drifting unfolds in an entirely different fashion between the photographs, which are episodic and discursive, and the film, which comprises in a sense a single protracted moment of transition between the cloaking and uncloaking of its (assumed) subject – insofar as this subject can be said to be what the film is about.

Ostensibly, *Teatro Amazonas* is a portrait of an audience set in real time synchronized to the exact duration of a single choral music composition. Because the orchestra pit is out of view of the fixed camera set on the stage, we cannot tell whether the performance is in fact live. This, with the lavishness of the setting and the motley informality of the audience members, reinforces the impression that we are witnessing an elaborately staged portrait, one in which the occasion of the musical performance is not the primary interest of those attending. The audience is there to be watched, and we are there to watch them being watched, audience to audience. It is a simple device nevertheless capable of establishing a low-level suspense of encounter with the Other, our as-yet-unknown counterparts. (Oddly, this sense of suspense is heightened by the chorus in the early minutes of the score, pushing the mood of the film to an almost Kubrickian state of menace, which eventually passes.) As the credits later suggest, however, this audience is not just there to be watched; they are there to *represent*. Each audience member is credited individually and grouped according to the neighborhood in which he or she lives. Thus, we may or may not realize, this is more than a portrait of an audience or of individual persons; it is a portrait of the city of Manaus through a cross-section of its citizens, a kind of pseudo-census gathered together in the heart of the city, Manaus's famed nineteenth-century opera house, Teatro Amazonas. For Lockhart, without telling us exactly, has represented *every* neighborhood in the city in her selection of audience members and, furthermore, without telling us at all, has met and interviewed each one of the 308 in small groups of friends or family, coming to address many by name in the course of the production.

Lockharts Brasilien-Projekt, das die in dieser Publikation abgedruckte Fotoserie und den Film *Teatro Amazonas* (1999) umfasst, zeigt vielleicht am deutlichsten, wie flexibel in dieser künstlerischen Praxis der Bezugsrahmen und, wie dehnbar die Form innerhalb der Grenzen einer bestimmten Werkgruppe ist. Wenn der allgemeine Standpunkt des Projekts undeutlich und nicht klar identifizierbar erscheint, so liegt das daran, dass er ebenso vielschichtig wie anpassungsfähig und situationsbedingt ist. Seine zahlreichen fotografischen und filmischen Momente bewegen sich je nach Gegenstand zwischen deutlicher Formulierung, Verschlüsselung und Verschiebung, so dass der Betrachter zuweilen ins Zweifeln gerät, ob das, was er sieht, tatsächlich das ist, was er sehen soll. Diese Bewegung läuft in den beiden Medien auf ganz unterschiedliche Weise ab: in den Fotos, die episodenhaft und diskursiv sind, anders als im Film, der eigentlich ein einziger, in die Länge gezogener Augenblick des Übergangs ist von der Verhüllung zur Enthüllung seines (vermutlichen) Gegenstands – soweit man überhaupt sagen kann, dass dieser Gegenstand das Thema des Films ist.

Augenscheinlich ist *Teatro Amazonas* das Porträt eines Publikums in Echtzeit, exakt synchronisiert auf die Dauer einer einzigen Chormusik. Da die auf der Bühne fixierte Kamera den Orchestergraben nicht erfasst, lässt sich nicht feststellen, ob es sich tatsächlich um eine Live-Aufführung handelt. In Verbindung mit der reichen Ausstattung und dem zwanglosen, bunt gemischten Publikum erweckt dies den Eindruck, dass wir ein sorgfältig arrangiertes Porträt betrachten, bei dem es den Zuhörern nicht primär um die Musik geht. Das Publikum ist da, um betrachtet zu werden, und wir sind da, um es beim Betrachtetwerden zu betrachten, Publikum gegen Publikum sozusagen. Es ist ein einfacher Kunstgriff, der aber dennoch eine unterschwellige Spannung auslöst in der Begegnung mit dem Anderen, unseren noch unbekannten Gegenspielern. (Seltsamerweise wird diese Spannung erhöht durch den Chor, der in den ersten Minuten eine fast Kubrick-haft bedrohliche Stimmung im Film erzeugt, die dann wieder abflaut.) Im Abspann wird später deutlich, dass dieses Publikum aber nicht nur da ist, um beobachtet zu werden, sondern selbst auch etwas *darstellt*. Jede einzelne Person aus dem Publikum wird namentlich erwähnt und dem Viertel, aus dem er oder sie stammt, zugeordnet. So kann man, wenn man will, erkennen, dass es sich um mehr als das Porträt eines Publikums oder einzelner Personen handelt.

It is certain, then, that Lockhart takes a personal interest in her individual human subjects and concerns herself with bringing them into her work through an exchange of activity or, at times, ideas, as may be seen in her photograph series, *Goshogaoka Girls Basketball Team* (1997) and film, *Goshogaoka* (1997), the immediate precursor of the Brazilian project. The choral music composition that forms the structural arc and duration of *Teatro Amazonas* is itself a dominant subject indicator in that it becomes the primary measure by which we perceive the audience to be cloaked or uncloaked, and thereby handled as a subject. Composed by Lockhart's collaborator, Becky Allen, the score delineates a single monotonic decrescendo of voices, starting deafeningly with twelve groups of five singers each, all intoning a full cycle of local vowel sounds, and gradually tapering off to a single barely audible group. The overall effect, befitting the camera's proscenium point of view, is of a massive sonic curtain slowly retracting to reveal the audience. For as the sound level decreases, the audience for the first time can be heard: as a desultory rustling, sibilance, and murmur of fidgeting human bodies. This moment, which we implicitly understand to be the peak moment of encounter, the essence of Lockhart's portrait, is, however, profoundly ambiguous as to the portrait's aims. We are brought through sound and image to a kind of ground zero of the audience and, by dint of little leakages of personality, some of the individuals within it. But, what do we find there? Not a revelation of the particular, so much as the realization of a universal: an audience that sounds like any other. We find a human surface reflective to our gaze while transparent to the audiovisual devices that have framed it. We find an artwork difficult to classify, even as a portrait.

This is a common realization with Lockhart's work. We do not know what we are looking at, except that we are looking at it intensely. If a portrait can be said to exceed a 'mere' recording, in that it may show that which by nature is hidden, then we may come to doubt that *Teatro Amazonas* is indeed a portrait or should be viewed as such. The revealing of the audience ultimately reveals little, and the little that it does reveal – the public demeanor, hints of social subgroups, little leakages of individual personality – starts to seem like a lot, as it comes to stand for all that must remain hidden, of which the film as a whole makes us acutely aware. Thus, in spite of the elaborate staging of the event, it is perhaps better that we

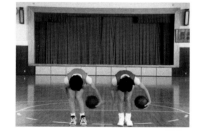

Goshogaoka, 1997 (film still/Standfoto)
16mm film
63 min./Min.
color-sound/Farb-Tonfilm
courtesy Blum & Poe, Santa Monica

Vielmehr ist es ein Porträt der Stadt Manaus in Form eines Querschnitts ihrer Bevölkerung, eine Art Pseudo-Volkszählung im Herzen der Stadt, in Manaus berühmtem Opernhaus Teatro Amazonas aus dem 19. Jahrhundert. Denn ohne dass Lockhart dies erwähnte, hat sie doch bei ihrer Auswahl des Publikums genau darauf geachtet, dass jedes Viertel der Stadt vertreten ist. Darüberhinaus hat sie – und auch das bleibt unerwähnt – jede der 308 Personen in kleinen Freundes- oder Familiengruppen interviewt, so dass sie am Ende der Produktion viele von ihnen namentlich kannte.

Zweifellos entwickelt Lockhart also ein persönliches Interesse an jeder einzelnen ihrer Figuren und achtet darauf, sie durch einen aktiven bzw. gedanklichen Austausch an ihrer Arbeit zu beteiligen. Dies lässt sich beispielsweise an ihrer Fotoserie *Goshogaoka Girls Basketball Team* (1997) ebenso ablesen wie an dem Film *Goshogaoka* (1997), der unmittelbar vor ihrem Brasilien-Projekt entstand. Auch die Chormusik, die die Grundstruktur für *Teatro Amazonas* liefert und die Dauer des Films bestimmt, ist selbst ein thematischer Indikator, weil sie das Maß angibt, in dem wir das Publikum verhüllt oder enthüllt sehen; denn das genau macht aus dem Publikum ein Thema. Die Musik, komponiert von Lockharts Mitarbeiterin Becky Allen, besteht aus einem einzigen monotonen Decrescendo der Stimmen. Sie beginnt ohrenbetäubend laut mit zwölf Gruppen zu je fünf Sängern, die alle zusammen einen Zyklus aus lokalen Vokalklängen anstimmen und allmählich auf eine einzige, kaum noch hörbare Gruppe reduziert werden. Die raumgreifende Wirkung, die dem Bühnenstandpunkt der Kamera entspricht, ist ein massiver Klangvorhang, der sich ganz langsam zurück zieht, so dass das Publikum zum Vorschein kommt. Denn in dem Maß, in dem der Tonpegel der Musik abnimmt, wird das Publikum zum ersten Mal hörbar: vereinzeltes Rascheln, Flüstern, Murmeln und zappelige Körper. Dieser Augenblick stellt sozusagen den Höhepunkt der Begegnung dar, das Wesen von Lockharts Porträt, und ist zugleich doch hinsichtlich seiner Zielsetzung höchst ambivalent. Durch Bild und Ton erleben wir das Publikum – und mittels kleinster persönlicher Zeichen auch einige Einzelpersonen – auf einer Art Nullpunkt. Aber was finden wir dort vor? Nicht so sehr das Persönlich-Besondere, sondern vielmehr Allgemeines: ein Publikum, das klingt wie jedes andere. Wir treffen auf eine menschliche Oberfläche, die unseren Blick widerspiegelt, während sie für die

take Lockhart's use of real time at face value and consider *Teatro Amazonas*, with respect to its human subjects at least, as a deceptively complex form of 'mere' recording: the audiovisual documentation (constructed record) of the reception of a musical performance. This affords us a glimpse into Lockhart's complex and profoundly ambivalent relation to filmic and photographic documentary, a relation that goes to the root of her inclination to shape-shift and hybridize throughout her work and, as witnessed throughout the Brazilian project, to simultaneously attend to and defer her human subject.

Perhaps most surprising in the Brazilian photograph series is the invocation of the aesthetic of social and/or ethnographic documentary and the association of this aesthetic with specific procedures of ethnographic research and data collection. Whereas in *Teatro Amazonas* and *Goshogaoka*, the traits of documentary are fully entwined in a complex of dominant artistic devices and thus appear latent, in the Brazilian photographs these traits are themselves dominant and foregrounded, suggesting a baseline by which the images may be viewed. The traces of scientism and the partial emulation of its aesthetic are highly uncharacteristic of Lockhart's best known work – though, for some of us, they do recall a period in her early photography that she has decisively left behind. Her ambivalent relation to documentary is indeed complicated. But her aversion to its scientist dimension is not, insofar as it approaches the status of the clinical gaze – specifically, that of medical photography, the primary object of her aversion. Of course, the Brazilian photographs demonstrate Lockhart's continued attraction to the potentially clinical, while at the same time appreciating the ways in which ethnographic documentary has already proven its capacity to supersede the clinical – for example, in the hands of a filmmaker like Jean Rouch, whose work informs the Brazilian photographs perhaps more than any other. Thus, emulation and aversion coincide in Lockhart's 'return' to documentary form, although in quite a different manner here than in her circuitous first departure from it.

In 1993, Lockhart faced an impasse in her work regarding its relation to medical photography, an impasse that would be overcome through an extraordinary act of transposition in her first film, *Khalil, Shaun, A Woman Under the Influence* (1994). She had been producing a series of fairly large-scale, sharp-focused, and depersonalized color portraits concentrating, usually disturbingly, on the blemished

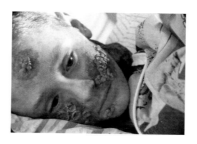

Khalil, Shaun, A Woman Under the Influence, 1994
(film still/Standfoto)
16mm film
16 min./Min.
color-sound/Farb-Tonfilm
courtesy Blum & Poe, Santa Monica

audiovisuellen Mittel, aus denen sie hervorgeht, durchlässig bleibt. Wir haben es mit einem Kunstwerk zu tun, das sich kaum einordnen lässt, nicht einmal als Porträt.

Diese Erkenntnis ist typisch für Lockharts Werk. Wir wissen nicht, was wir da eigentlich anschauen, sondern nur, dass wir es sehr intensiv tun. Wenn man davon ausgeht, dass ein Porträt mehr ist als 'bloße' Wiedergabe, weil es etwas zutage fördert, was von Natur aus verborgen ist, dann sind Zweifel daran angebracht, ob *Teatro Amazonas* tatsächlich ein Porträt ist oder als solches betrachtet werden sollte. Die Enthüllung des Publikums verrät letztendlich wenig, und das Wenige, das sie verrät – das Verhalten in der Öffentlichkeit, Hinweise auf soziale Gruppenzugehörigkeit, kleine Anzeichen von Persönlichem – erscheint plötzlich als sehr viel, denn es steht für all das, was im Verborgenen bleiben muss; das macht der Film überaus deutlich. So ist es vielleicht trotz der Sorgfalt, mit der das Ereignis in Szene gesetzt wurde, besser, dass wir Lockharts Verwendung von Realzeit für bare Münze nehmen und *Teatro Amazonas*, zumindest hinsichtlich seiner menschlichen Aspekte, als täuschend-vielschichtige Form der 'bloßen' Wiedergabe betrachten: eine audiovisuelle Dokumentation (eine konstruierte Wiedergabe) der Rezeption eines Konzerts. Dies gibt einen Einblick in Lockharts ebenso komplexe wie zutiefst ambivalente Beziehung zu Dokumentar-Film und -Fotografie, eine Beziehung, die ihrer immer präsenten Neigung zu Form-Verschiebung und Genre-Überkreuzung entspringt sowie dem Hang, sich ihrem menschlichen Gegenstand zu nähern und ihn zugleich auch wieder zu entrücken, wie wir es in ihrem Brasilien-Projekt beobachten können.

Am überraschendsten ist an den Brasilien-Fotos vielleicht die Beschwörung der Ästhetik von gesellschaftlicher und/oder ethnographischer Dokumentation sowie die Verknüpfung dieser Ästhetik mit bestimmten Vorgehensweisen der ethnographischen Forschung und Datenerhebung. Während die Wesensmerkmale der Dokumentation in *Teatro Amazonas* und *Goshogaoka* vollständig in einen Komplex dominanter künstlerischer Mittel eingeflochten sind und daher nur latent erscheinen, treten diese Eigenheiten in den Brasilien-Fotos selbst in den Vordergrund und geben die Richtung vor, in der die Bilder zu interpretieren sind. Die Spuren der Wissenschaftlichkeit und die teilweise Nachahmung ihrer Ästhetik sind höchst untypisch für Lockharts bekannteste Werke. Allerdings werden einige von

surfaces of her subjects' skin. Between the cruel precision of the dermatological gaze and her interest in its objectified human subject, Lockhart found herself caught up in a complicity that she could not overcome through subtle tweakings of the clinical photographic model. In spite of her recourse to that model's least clinical variants, found in recent medical journals, where the treatment of the subject had become more 'sympathetic,' that is, more narrativized and aesthetic – hence, in a sense, *more* exploitative – she came to the realization that clinical photography was itself plumbing the affective limits of its own potential, thereby short-circuiting the potential of her relation to it. At the same time, her research was showing her the extent to which popular culture – horror films in particular – had been feeding off the formulae and anxiety of the clinical gaze. Two very different but apposite films then became study points for an incipient shift in her practice: one, Georges Franju's *Eyes Without a Face* (1959), a horror classic in which narrative and clinical documentary are conflated; the other, makeup artist Dick Smith's film tests of his work on child actress Linda Blair for William Friedkin's *The Exorcist* (1973), a 'clinical' documentary owing nothing to the exigencies of medical science.

With *Khalil, Shaun, A Woman Under the Influence* Lockhart made a defining leap away from definition, as it were, and toward hybridity and drama. By the same token, she defined both her attraction and aversion to the clinical. True, she found repellent the power of the clinical gaze to instill a paranoid body image in its subjects and lay audience. But the inherent anxiety of such an image was also a marker of visual power: a power of horror, perhaps, yet one that had the capacity to motivate an intense, voyeuristic kind of looking. She had been drawn to this intensity, and indeed to the clinical veneer of anonymity, which offered a permission to look intensely *and* freely – a pairing that, to this day, constitutes something of an ideal in Lockhart's work. The problem, however, was not just a matter of her own sense of complicity in dehumanizing effects; it was a problem of artistic reception. One could not approach the human subject through a clinical model and not be perceived as introducing a 'clinic' of the clinical – that is, a critique or argument about its onerous effects and implications. Furthermore, it was the tenor of the times that such a perception would necessarily imply a politics of subjectivity or identity that Lockhart was illdisposed to enjoin. In either case, 'intense and free

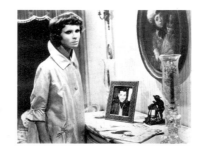

Georges Franju
Les Yeux Sans Visage, 1959 (film still/Standfoto)
35mm film
90 min./Min.
black-and-white-sound/S/W-Tonfilm
courtesy The Museum of Modern Art, Film Stills
Archive, New York

uns sich an eine frühe fotografische Periode bei Lockhart erinnert fühlen, die sie jedoch endgültig hinter sich gelassen hat. Ihre Beziehung zum Dokumentarischen ist in der Tat kompliziert. Aber ihre Abneigung gegen dessen wissenschaftliche Dimension – sofern es sich des klinischen Blicks bedient wie die Medizin-Fotografie – ist nicht der Kern der Sache. Natürlich wird in den Brasilien-Fotos Lockharts ungebrochener Hang zum potentiell Klinischen ersichtlich. Zugleich aber schätzt sie die Fähigkeit der ethnographischen Dokumentation, über den klinischen Aspekt hinaus zu gehen. Dies wird beispielsweise bei einem Filmemacher wie Jean Rouch deutlich, dessen Werk die Brasilien-Fotos vielleicht mehr beeinflusst hat als alles andere. Abneigung und Nachahmung fallen bei Lockharts 'Rückkehr' zur Form des Dokumentarischen also in eins, wenngleich auf ganz andere Weise als in ihrem früheren Ansatz.

In 1993 gesiet Lockhart 1993 mit ihrer Arbeit und deren Bezug zur Medizin-Fotografie in eine Sackgasse. Sie überwand diese Situation mit einer ganz ungewöhnlichen Form von Verlagerung in ihrem ersten Film *Khalil, Shaun, A Woman Under the Influence* (1994). Eine Serie von verhältnismäßig großformatigen, scharf fokussierten, unpersönlichen Porträts war entstanden. Dabei hatte Lockhart sich – was normalerweise irritierend wirkt – auf die verunstaltete Haut ihrer Modelle konzentriert. Zwischen dem gnadenlosen dermatologischen Blick und dem Interesse an ihrem menschlichen Gegenstand war sie sozusagen Gefangene einer Komplizenschaft, der sie auch durch subtil erhaschte Momente von ihrem klinischen Modells nicht entkommen konnte. Obwohl sie schon auf die eher unklinischen Varianten zurückgriff und sich an neueren Medizin-Journalen orientierte, die ihren Gegenstand 'sympathischer' darstellten, das heisst narrativer und ästhetischer – in gewisser Weise also auch ausbeuterischer-, wurde ihr klar, dass die klinische Fotografie selbst die Grenzen ihres affektiven Potentials sondierte. Ihre eigene Beziehung wurde dadurch gewissermaßen ausgesetzt. Zugleich erkannte sie durch ihre Recherchen, wie sehr die populäre Kultur, vor allem Horrorfilme, sich aus den Rezepturen und dem Nervenkitzel des klinischen Blickes speisten. Zwei ganz gegensätzliche Filme gaben zu diesem Zeitpunkt den Anstoss zu einer beginnenden Veränderung ihres Ansatzes: zum einen Georges Franjus *Augen ohne Gesicht* (1959), ein Horror-Klassiker, der seine narrative Struktur mit dem

'looking' would have to take a back seat to discourse. *Khalil, Shaun, A Woman Under the Influence* would leap over this problem by transposing its terms to those of popular (as opposed to decidedly unpopular) culture, pursuing horror, documentary, and drama down an entirely different path.

Half-documentary à la Dick Smith, half-family melodrama via a perverse admixture of John Cassavetes and *The Exorcist*, the film shifted the clinical frame of reference so completely to that of its cultural mirror that Lockhart was able to achieve her intense kind of looking (at skin) – indeed, to exaggerate it to the point of caricature through a horrific excess of makeup – without the guilty pathos of an exploited (afflicted) human subject. Here was a moment of liberation from the constraints of her prior conception of her work – notably, one that depended on substituting the role of the portrait subject with that of the 'actor,' professional or otherwise. This distinction is perhaps clearest in the film and the photograph series derived from it, *Shaun* (1993), but it is crucial in discerning the subtle thread of documentary that would run through the photographs soon to follow. *Shaun* is a classic Lockhart hybrid: a *documentary* photograph series (stages of makeup application) of a human subject cast in a role, a role in which he plays himself as an actor. That is, while the photographs draw attention to the idea of a role being played, and thus defer the individual, it is not so much the role but the individual deferred that is the subject of the photographs. The role is merely a kind of trapping device or leaky container from which little expenditures or leakages of personhood may spill. Lockhart, like Cassavetes, desires these little leakages because they are accidental and defy her control. They are what emanates from the individual, and only the individual, in the moment of his deferral, and she is there to record the moment.

Thus, through her film, Lockhart found a circuitous means of conveying individual persons without defining them, to make portraits that are not portraits, for the portrayal always lies elsewhere. In doing so, she found an alternative to the anonymous looking of the clinical: a kind of looking that is never sure of its source because it is always shifting, or reaching for some phantom element that is perhaps just out of its reach. In the *Audition* series (1994), she portrays a scene from François Truffaut's *L'argent de poche* (Small Change, 1976), pairing preadolescents in a first kiss kind of moment. As in *Shaun*, there is the pretext of a screen test, but no film is to be made,

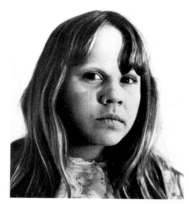

Dick Smith
Production stills from William Friedkin,
The Exorcist (1973)/
Fotos von der Aufnahme zu *Der Exorzist* (1973)
von William Friedkin.
courtesy Dick Smith

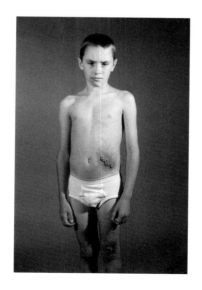

Shaun, 1993
5 framed chromogenic prints/
gerahmte Farb-Negativ-Drucke (detail/Detail)
35.6 x 199.4 cm
courtesy Blum & Poe, Santa Monica

klinischen Dokumentarfilm verbindet, zum anderen die Testfilme des Visagisten Dick Smith von seiner Arbeit an Linda Blair, dem Kind, das in William Friedkins Film *Der Exorzist* (1973) spielte. Letzterer war eine 'klinischer' Dokumentarfilm, allerdings ohne medizinisch-wissenschaftlichen Anspruch.

Mit *Khalil, Shaun, A Woman Under the Influence* entfernte Lockhart sich weiter von der bisherigen Definition ihrer Arbeit und wandte sich verstärkt der Überkreuzung von Genres und dem Drama zu. Auf diese Weise definierte sie zugleich sowohl ihre Neigung zum Klinischen als auch ihre Abneigung dagegen. Zwar fühlte sie sich durch die Macht des klinischen Blicks, seinem Gegenstand ebenso wie dem Laienpublikum ein paranoides Körperbild zu vermitteln, abgestossen, doch der Nervenkitzel, der solchen Bildern innewohnt, markierte auch eine visuelle Macht: eine Macht des Horrors vielleicht, die aber eine intensive, voyeuristische Art des Sehens auszulösen vermochte. Sie fühlte sich angezogen von dieser Intensität, von dem klinischen Schein der Anonymität, der es erlaubte, intensiv und ungeniert hinzusehen – eine Kombination, die bis heute in Lockharts Werk eine Art Ideal darstellt. Das Problem bestand jedoch nicht darin, dass sie sich selbst als Komplizin der Entmenschlichung, es lag vielmehr in der künstlerischen Wahrnehmung. Es war nämlich nicht möglich, sich dem Menschen in Gestalt eines klinischen Modells zu nähern, ohne sich dem Verdacht auszusetzen, eine 'klinische Darstellung' des Klinischen liefern zu wollen, das heisst eine Kritik von dessen bedenklichen Implikationen. Darüberhinaus herrschte damals die Vorstellung, dass eine solche Wahrnehmung notwendigerweise eine Politik der Subjektivität bzw. Identität mit einschloss, eine Vorstellung, mit der Lockhart nichts zu tun haben wollte. Auf jeden Fall bedeutete 'intensives *und* ungeniertes Hinsehen' Distanz zum Diskurs. *Khalil, Shaun, A Woman Under the Influence* setzte sich über dieses Problem hinweg, indem der Film auf populäre (im Gegensatz zu bewusst unpopulärer) Kultur zurückgriff und die Genres Horror, Dokumentation und Drama auf ganz unterschiedliche Weise nutzte.

Halb Dokumentarfilm à la Dick Smith, halb Familien-Melodram vermittels einer perversen Beimischung von John Cassavetes und *Der Exorzist*, verlagerte der Film den klinischen Bezugsrahmen so vollständig auf den seines kulturellen Spiegelbildes, dass Lockhart ihr intensives Hinschauen (auf die Haut) inszenieren konnte – ja durch einen horrenden Make-up-Exzess bis zur Karikatur übertreiben

nor named, as Lockhart's titles give us only the first names of her 'actors.' The photographs are the work, and the work is the moment, a moment where the role presses the individual into an awkward embrace with Lockhart there to record it. It matters little that we do not know whether the kiss is intended to represent a first kiss or is, in fact, the first kiss of these young people. Their bodies tell us what we can already deduce: this is their first kiss *before the camera*. So while Lockhart portrays the scene, which is always in some sense elsewhere (with Truffaut), the 'actors' steal it by conveying *themselves* in a here and now afforded by a role.

As the idea of the role, with its paradoxical double action of unconcealment through disguise, emerged with an expanded notion of documentary as the hybridizing agent in Lockhart's revised practice, it too expanded. It had already replaced the idea of the (afflicted) subject's 'condition' in *Khalil, Shaun, A Woman Under the Influence* and was now extending to the condition of the picture itself. The faces of *Lily* and *Jochen* (both 1994) are still rendered quite clinically, with distant expressions and close focus on the surfaces of their skin. Yet this clinical gaze cannot take command over the scene because of the background against which the figures have been set – respectively, the Pacific Ocean, 8 a.m., and North Sea, 8 p.m., as the titles tell us. Lockhart's watery set piece characterizes the figures as distant counterparts in some kind of romance, a relation they in no way express but is nonetheless signified for them. They do not act the role, they *absorb* it by way of our impressions of the scene. Lockhart's pictorial language was now beginning to take the role of characterization upon itself, employing a cinematic sense of mise-en-scène as its chief device – though making no further overt reference to specific films. Nearly all of the untitled large-scale color photographs of 1995-96 pursue this pictorial language to greater and greater degrees of scenic involution and mystery. And in nearly all of them the human subject is obliquely posed, many with back to camera: a figure of vacancy, stillness, and deferral within a picture of tense visual expectation. Curiously, a few of these poses echo those seen in the artist's rephotographed family snapshots, which she has produced from 1996 to the present day. In these nostalgic images, she, her sister, mother, and father appear as solitary or paired figures, typically with backs to camera, before natural vistas or more domestic placid scenery. The sense of longing and deferral in these images offers a

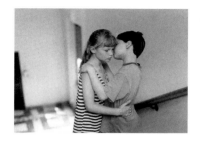

Audition Two: Darija and Daniel, 1994
5 framed chromogenic prints/
gerahmte Farb-Negativ-Drucke (detail/Detail)
124.5 x 155 cm
courtesy Blum & Poe, Santa Monica

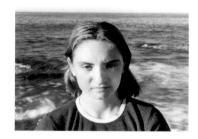

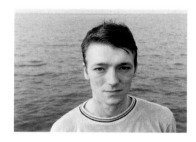

Lily (Approximately 8 a.m., Pacific Ocean);
Jochen (Approximately 8 p.m., North Sea), 1994
2 framed chromogenic prints/
gerahmte Farb-Negativ-Drucke
78.7 x 228.6 cm
courtesy Blum & Poe, Santa Monica

konnte – ohne das schuldbewusste Pathos eines ausgebeuteten (gequälten) menschlichen Subjekts. Nun konnte sie sich von den Beschränkungen ihres früheren Konzepts befreien, vor allem indem sie das porträtierte Subjekt durch den – professionellen oder laienhaften – 'Schauspieler' ersetzte. Diese Unterscheidung zeigt sich vielleicht am deutlichsten in dem Film und der daraus hervorgegangenen Fotoserie *Shaun* (1994). Sie ist wichtig, um jenen subtilen dokumentarischen Faden zu erkennen, der sich schon wenig später durch ihre Fotografien ziehen wird. *Shaun* ist eine klassische Lockhart-Kreuzung: eine *dokumentarische* Fotoserie (die verschiedenen Stadien des Schminkens) von einem Menschen, der eine Rolle angenommen hat – eine Rolle, in der er sich selbst als Schauspieler spielt. Während also die Fotos die Aufmerksamkeit auf eine zu spielende Rolle lenken und das Individuum dahinter verschwindet, ist der Gegenstand des Fotos eben doch nicht die Rolle, sondern das 'verschwundene' Individuum. Die Rolle ist lediglich ein Köder oder ein durchlässiger Behälter, aus dem Persönliches in kleinen Mengen austritt. Auf diese kleinen Austrittsmengen hat Lockhart es, wie Cassavetes, abgesehen, denn sie sind zufällig und entziehen sich ihrer Kontrolle. Sie sind das, was das Individuum, und nur das Individuum, ausstrahlt im Augenblick seines Verschwindens. Genau diesen Augenblick versucht sie einzufangen.

Durch ihren Film fand Lockhart eine umfassende Methode, individuelle Personen vorzuführen, ohne sie definieren zu müssen, Porträts herzustellen, die keine Porträts sind, denn der Inhalt des Porträts liegt immer anderswo. Auf diese Weise fand sie eine Alternative zur Anonymität des klinischen Blicks: eine Art des Sehens, das sich seiner Quelle niemals sicher ist, weil es ständig die Richtung wechselt oder hinter irgendeinem phantomhaften Element her ist, das vielleicht ausserhalb seiner Reichweite liegt. In ihrer Serie mit dem Titel *Audition* (1994) porträtiert Lockhart eine Szene aus Francois Truffauts Film *L'argent de poche* (Taschengeld, 1976); sie zeigt darin zwei Präadoleszenten 'beim ersten Kuss'. Scheinbar handelt es sich auch hier wieder um einen Testfilm wie bei *Shaun*, aber tatsächlich soll gar kein Film gedreht werden, auch nicht angeblich, und so nennt Lockhart denn auch nur die Vornamen ihrer 'Schauspieler'. Die Fotos sind das Werk, und das Werk ist der Augenblick, jener Augenblick, in dem die Rolle das Idividuum in eine heikle Verbindung mit der fotografierenden Künstlerin bringt. Dabei ist es kaum

powerful, though muted, personal counterpoint to the cinematic grandeur of the large-scale photographs, which appear to derive from them in ways that remain essentially indeterminate and private.

It was not until Lockhart's work in Japan the following year that her expanded notions of documentary would take priority over her cinematic approach to scenic characterization, in the process reanimating the human subject in her work. This was to an extent born of necessity, for she had selected a subject distinguished more by its activity than its specific setting. Traveling on a grant with the expectation of making a film on farming, she happened upon a practice session of a middle school girls basketball team in a rural town and knew at once that this would be her subject. The sport and setting seemed so American, with its familiar multipurpose gym/stage/auditorium setup, that it struck her as the ideal milieu for working with a subject so foreign to her. Besides providing her with an initial frame of reference, the milieu would announce at the outset its own Americanism in lieu of any such self-declaration made by her work. As it turns out, this prefatory framing device would become something of a redundancy as Lockhart's project developed. For the film, *Goshogaoka*, and photograph series, *Goshogaoka Girls Basketball Team*, are encoded with multiple layers of Americanism that, obtusely enough, provide the ad hoc pattern of familiarity and sameness through which the unfamiliar and different may appear.

Having studied the various routines and drills of the girls' practice sessions, Lockhart reconfigured what she saw, with the assistance of the choreographer Stephen Galloway, into a series of six ten-minute segments comprising a fairly comprehensive sampling of the group's activities. This reconfiguration was itself a kind of double Americanism, emulating on one hand the 'minimal' schemas and everyday movement associated with the Judson Dance Theater in the 1960s (Yvonne Rainer, Steve Paxton, Lucinda Childs, et al.) and its West Coast progenitor Anna Halprin, and, on the other, the simplified schemas and real time of structural film and/or performance documentary. The result is a hybrid form, in which patterns of the American avant-garde and glimpses of the Japanese everyday convene. The accomplishment of *Goshogaoka*, however, lies not in the inventiveness of its choreography or the durational structure of the film itself but in the focus these framing devices bring to the rote gracefulness

Untitled, 1996
framed chromogenic print/
gerahmter Farb-Negativ-Druck
129.5 x 101.6 cm
courtesy Blum & Poe, Santa Monica

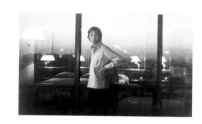

Untitled, 1996
framed chromogenic print/
gerahmter Farb-Negativ-Druck
185.4 x 276.9 cm
courtesy Blum & Poe, Santa Monica

Untitled, 1996
framed chromogenic print/
gerahmter Farb-Negativ-Druck
104.1 x 81.3 cm
courtesy Blum & Poe, Santa Monica

von Bedeutung, dass wir nicht wissen, ob der Kuss einen ersten Kuss darstellen soll, oder ob es sich tatsächlich um den ersten Kuss zwischen den beiden jungen Leuten handelt. Doch eines verraten ihre Körper ganz deutlich: dies ist ihr erster Kuss *vor der Kamera*. Während also Lockhart die Szene porträtiert, die (im Truffaut'schen Sinne) immer gewissermaßen anderswo ist, stehlen die 'Schauspieler' sich den Kuss, indem sie *sich selbst* in eine Situation begeben, die die Rolle ihnen gewährt.

Die Idee der Rolle mit ihrer paradoxen Doppelstrategie der Enthüllung durch Verkleidung führte den erweiterten Dokumentations-Begriff als Prinzip der Genre-Überkreuzung in Lockharts neue Praxis ein und erfuhr damit zugleich selbst eine Erweiterung. In *Khalil, Shaun, A Woman Under the Influence* war sie bereits an die Stelle der Idee vom 'Zustand' des (gequälten) Subjekts getreten. Nun bezog sie sich auf den Zustand des Bildes selbst. Die Gesichter von *Lily* und *Jochen* (beide 1994) sind zwar immer noch auf sehr klinische Weise dargestellt, mit distanziertem Ausdruck und Fokussierung auf die Oberfläche der Haut, doch die Figuren sind vor einem Hintergrund fotografiert – Pazifik, 8 Uhr morgens, Nordsee, 8 Uhr abends, wie der Titel verrät –, der den klinischen Blick konterkariert. Lockharts Meeres-Hintergrund charakterisiert die Figuren als distanziertes Gegenstück zu einer Art Romanze, eine Beziehung, die sie zwar selbst keineswegs zum Ausdruck bringen, für die sie aber dennoch quasi symbolisch stehen. Sie spielen die Rolle nicht, sondern *schlüpfen hinein*, weil wir sie darin sehen. Lockharts Bildsprache übernimmt fortan die Rolle ihrer eigenen Charakterisierung, indem sie in kinohafter Weise inszeniert – wenngleich sie nicht mehr auf bestimmte Filme Bezug nimmt. Nahezu alle großformatigen Farbfotografien ohne Titel aus den Jahren 1995-96 bedienen sich in zunehmendem Maß dieser Bildsprache der szenischen Entrückung und Mysteriosität. Und in fast allen Fotos ist die menschliche Figur mehr oder weniger indirekt plaziert, viele mit dem Rücken zur Kamera: Gestalten der Leere, der Reglosigkeit, der Verschleierung in einem Bild voller dichter visueller Erwartung. Kurioserweise erinnern einige dieser Posen an die Familien-Schnappschüsse, die die Künstlerin reproduziert hat und seit 1996 bis heute weitergeführt. In diesen nostalgischen Fotos erscheinen sie, ihre Schwester und ihre Eltern einzeln oder paarweise, oft mit dem Rücken zur Kamera, in der Natur oder in häuslicher Beschaulichkeit. Verlangen und Entrückung setzen in

and physical coordination of the group. Within Lockhart's framework of structured formality and patience, subtle yet poignant cultural differences begin to surface alongside details of individual difference among the girls: strengths and weaknesses, styles of bodily comportment, indications of team hierarchy, and so forth. These are the *puncta*, the tiny incisions into the social real, that, upon reflection, make us question the circuitous approach of Lockhart's 'costume documentary' – a term that applies both figuratively *and* literally, for the girls have been dressed in three changes of 'uniforms' designed and manufactured by the artist in collaboration with the girls, their mothers, and some of their teachers.

At the same time, these subtle differences and details help us to understand Lockhart's circuitous approach, as it were, from the inside out. The fixed camera centered on the frame of the stage, the symmetry of the minimal choreography, the regularity of the film segments, all these enfolded tropes of aesthetic formality construct a backdrop of decorum and ideality that sets the non-ideal, the subtle and indecorous inflections of human detail, into the sharpest of contrasts. Perhaps more importantly, it orients us to the aesthetics of the girls' physical movements, the artfulness of their routines, and their individual talents, as if to engage the logic: if art demands its proper frame, a proper frame demands its art. In this respect, *Goshogaoka* is quite portrait-like, in that it invites us to perceive the girls honorifically, as artists, as dancers. In the photograph series, *Goshogaoka Girls Basketball Team*, the register of ideality shifts to the side of the subject. Lockhart asked the girls to come up with their own poses based on action shots from a variety of sports magazines, a task they took to with great enthusiasm. The result, obviously, would have little to do with dance and everything to do with basketball fantasy, for the girls naturally gravitated to shots (in both senses of the word) of their favorite stars. These images represent a kind of idealized self-portraiture, then, facilitated by Lockhart but essentially self-directed by the girls. What we see in their static poses, emulating moments of frozen action, is not the girls' physical talent, but the desire and will undergirding it. Here is the obverse of the will to physical and social activity: a fantasy of becoming static, iconic, literally, becoming photographic. Yet within the series Lockhart includes several hesitant, even dreamy, poses in which the subject appears

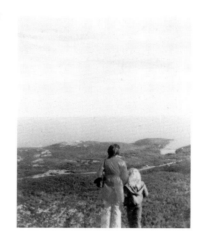

Untitled Study (re-photographed snapshot #2),
1995
framed chromogenic print/
gerahmter Farb-Negativ-Druck
41.9 x 37.1 cm
courtesy Blum & Poe, Santa Monica

diesen Bildern einen starken, wiewohl sprachlosen persönlichen Kontrapunkt zur kinematografischen Pracht der großformatigen Fotos. Letztere scheinen auf unerklärte und private Weise von den Familienfotos herzurühren.

Erst in der Arbeit, die Lockhart im darauffolgenden Jahr in Japan produzierte, gewann ihr erweiterter Dokumentations-Begriff Oberhand über ihre kinematografische Vorgehensweise in der szenischen Charakterisierung, wodurch das menschliche Subjekt quasi zu neuem Leben erwachte. Dies hatte sich aus einer gewissen Notwendigkeit heraus ergeben, denn die dargestellten Personen zeichneten sich diesmal weniger durch eine bestimmte Umgebung aus, sondern durch das, was sie taten. Als Stipendiatin war sie mit der Erwartung angereist, einen Film über die Landwirtschaft zu drehen. Doch zufällig sah sie eine Gruppe Mittelschülerinnen beim Basketball-Training in einer ländlichen Kleinstadt und wusste sofort, dass sie ihr Thema gefunden hatte. Sowohl der Sport als auch das vertraute Ambiente mit der als Turnhalle, Theater und Auditorium genutzten Halle erschienen ihr so typisch amerikanisch, dass sie darin genau den richtigen Ort erkannte, um an einem für sie so fremden Thema zu arbeiten. Dieses Milieu lieferte ihr den Bezugsrahmen und demonstrierte von Anfang an seinen Amerikanismus, ohne dass ihre Arbeit dies hätte erst erklären müssen. Im Laufe des Projekts erwies sich dieser anfängliche Rahmen mehr oder weniger als überflüssig, denn in dem Film *Goshogaoka* und der Fotoserie *Goshogaoka Girls Basketball Team* verbergen sich so viele Schichten des Amerikanismus, dass sie verblüffenderweise eben jene Vertrautheit und Ähnlichkeit vorführen, durch die das Unvertraute und Andere hindurch scheint.

Nachdem Lockhart Training und Drill der Mädchen genau studiert hatte, fasste sie mit der Hilfe des Choreografen Stefen Galloway ihre Eindrücke in einer Serie aus sechs zehnminütigen Segmenten zusammen, die einen ziemlich exakten Überblick über die Aktivitäten der Gruppe geben. Diese Serie war selbst eine Art doppelter Amerikanismus, weil sie einerseits die 'Minimal'-Schemen und jene Alltagsbewegungen nachahmte, die in den 1960er Jahren das Judson Dance Theater (Yvonne Rainer, Steve Paxton, Lucinda Childs, et.al.) und seine Vorläuferin an der Westküste, Anna Halprin, benutzten, und andererseits die vereinfachte Schematik sowie die Realzeit-Struktur des Dokumentarfilms und/oder der Performance

disengaged from this process of emulation and more interested in what is going on around her, suggesting that some of the girls' basketball fantasies are indeed about becoming social, not ideal.

Thus, we circulate back toward our first impression of the subject in *Goshogaoka*: a line of girls filing into a generic social space: a sense of group with a sense of familiarity. It is perhaps best that the circuitousness of Lockhart's 'costume documentary' be understood quite simply through its etymological root, inasmuch as it is indeed circuit-like; it involves the creation of indirect paths. These may in fact be impulsive and appear somewhat arbitrary – they are, first and foremost, artistic – but they afford a kind of engagement with her subject that directness might have intimidated, an engagement analogous to the hand holding a circuitous path requires. Of course, there is an undeniable *sleight of hand* at work here, for *Goshogaoka*'s simple schemas and minimalism appear to belie this kind of touchy engagement in the same sense that certain of her more recent documentary-style photographs, including many in the Brazilian series, appear to belie dimensions of sentiment through their conceptual or scientist demeanor. But Lockhart's procedural *métier* is, after all, the false impression and cross-purpose, as her entanglements with the clinical gaze have born out, and continue to bear out in her ongoing employment of cool, dispassionate artistic means to shrewdly affective ends.

As I have noted, *Goshogaoka* and *Goshogaoka Girls Basketball Team* are the precursors to the Brazilian project. The key motif connecting them is the fixed camera centered on the frame of the stage in *Goshogaoka*, a motif Lockhart sought to deal with again but in reverse, as we now see it in *Teatro Amazonas*. The common role of the settings in the two films is quite evident. *Goshogaoka*'s prefatory Americanism and *Teatro Amazonas*'s Europeanism both ascribe an initial point of view to Lockhart's respective projects. Notably, it was the director Werner Herzog who supplied the idea to set the new film in Manaus's famed opera house, as this location was a centerpiece in his culminating magnum opus, *Fitzcarraldo* (1982), a film that has come to symbolize the limits of messianic creative vision both for its eponymous main character and for the director himself. Lockhart's relation to this symbology remains unclear, though her affinity with the director's films is long held, as it is with subjects and settings foreign to her and, one might say, far-flung

Untitled, 1996
framed chromogenic print/
gerahmter Farb-Negativ-Druck
129.5 x 104.1 cm
courtesy Blum & Poe, Santa Monica

Werner Herzog
Fitzcarraldo, 1982 (film still/Standfoto)
35mm film
158 min./Min.
color-sound/Farb-Tonfilm
courtesy The Museum of Modern Art, Film Stills
Archive, New York

aufgriff. Das Ergebnis ist ein hybrides Gemisch, in dem sich Muster der amerikanischen Avantgarde mit Einblicken in den japanischen Alltag verbinden. Doch die Leistung von *Goshogaoka* liegt weder im Einfallsreichtum seiner Choreografie noch in der Zeitstruktur des Filmes selbst, sondern darin, dass er den Blick auf die routinemässige Anmut und physische Koordination dieser Gruppe lenkt. In Lockharts strukturierter Formalität und Ausdauer tauchen subtile, aber prägnante kulturelle Eigenheiten zusammen mit individuellen Unterschieden zwischen den Mädchen auf: Stärken und Schwächen, Körperhaltungen, Anzeichen hierarchischer Strukturen im Team und so weiter. Genau dies sind die entscheidenden Punkte, die kleinen Einblicke in die gesellschaftliche Realität, die die Frage aufwerfen, um was es bei Lockharts komplexem Ansatz der 'Kostüm-Dokumentation' eigentlich geht – ein Begriff übrigens, der im wörtlichen wie im übertragenen Sinn zutrifft, denn die Mädchen trugen drei verschiedene 'Uniformen', die die Künstlerin zusammen mit den Mädchen, ihren Müttern und einigen Lehrern entworfen und genäht hat.

Zugleich helfen uns diese subtilen Unterschiede und Details, Lockharts komplexe Methode zu verstehen, mit der sie die Dinge von innen her zu begreifen sucht. Die feststehende Kamera, die auf das Bühnenrechteck ausgerichtet ist, die Symmetrie der minimalhaften Choreografie, die gleiche Länge der Filmsegmente – all diese formal-ästhetischen Elemente schaffen eine Ordnung, einen Idealzustand, der zu den nicht-idealen, subtilen, aus der Ordnung ausscherenden Anklängen menschlicher Details in scharfem Gegensatz steht. Wichtiger noch ist aber vielleicht die Tatsache, dass auf diese Weise unsere Aufmerksamkeit auf die physischen Bewegungsabläufe der Mädchen gelenkt wird, auf ihre Geschicklichkeit und individuellen Talente, so als läge in ihnen eine Logik verborgen: wenn die Kunst ihren eigenen Rahmen braucht, dann braucht der Rahmen seine eigene Kunst. *Goshogaoka* ist deshalb fast wie ein Porträt, weil es uns einlädt, die Mädchen voller Hochachtung zu betrachten, als Künstlerinnen, als Tänzerinnen. In der Fotoserie *Goshogaoka Girls Basketball Team* wird der Idealzustand auf die Ebene des fotografierten Gegenstands verlagert. Lockhart bat die Mädchen, auf der Grundlage von Aufnahmen in verschiedenen Sportmagazinen ihre eigenen Posen zu entwickeln, und sie folgten der Aufforderung mit grosser Begeisterung. Das Ergebnis hatte wenig mit Tanz zu tun, dafür viel mit Basketball-

artistic enterprises in general – of which *Goshogaoka* and *Teatro Amazonas* are prime examples. For some time prior to the planning of *Teatro Amazonas* she had been contemplating the idea of working with an ethnographer or anthropologist in some way, and as her plans for the film coalesced, the two ideas came together as the initial thinking for the Brazilian photograph series.

Because the private wealth that originally built the opera house in 1896 had been fed by the onset of the region's half-century-long rubber monopoly, now long since expired, it seemed fitting to take rubber production as her point of departure for the series. This led her to an anthropologist, Ligia Simonian, planning field work in the Rio Aripuanã region of the Amazon on the role of women in the rubber tapping industry, and, by happenstance, to Isabel Soares de Souza, planning a study of the bartering system on a tiny island near the mouth of the Amazon, Apeú-Salvador, in the province of Pará – coincidentally the eponym of the Pará rubber tree, the source of the greatest quantity and finest quality of natural rubber in South America. The photograph series would derive from these two separate expeditions and thus may be divided into two main groups: river photographs and island photographs. They are clearly quite different in character. The river series, shot over a seventeen-day period, is naturally the more linear and temporal, owing to the route taken up and down the river and the village to village schedule of the boat trip. At each stop, the anthropologist would interview one or more families in the common room of their dwelling, with Lockhart and cameraman sitting in, after which photographs were taken of the vacated interview location and some of the family's collection of snapshots. Given the empty interview locations and the rephotographed snapshots, the river series is also the more indirect of the two. The island series, on the other hand, is relatively direct with respect to its human subject and neither linear nor particularly temporal, for all of the photographs were taken within the period of a single arrival and departure. Although Lockhart shot a wide variety of photographs on the tiny island, traversing the same territory over and over again as befits island living, she selected to include only those of the inhabitants in the series, hence its more portrait-like character.

The most apparent common trait between the two series is the patterning of documentation formats within them, suggesting the exigencies of data collection or 'survey,' and indeed the titles of the

Fantasien, denn die Mädchen neigten natürlich zu (Schnapp-)Schüssen (im doppelten Wortsinn) von ihren Lieblings-Stars. Die Bilder sind eine Art idealisierter Selbstporträts, die Lockhart zwar ermöglicht hat, die im wesentlichen aber von den Mädchen selbst in Szene gesetzt wurden. In ihren statischen Posen eigefrorener Nachahmung geht es nicht um die physischen Talente der Spielerinnen, sondern um die Wünsche und den Willen, der sie antreibt. Es ist die Kehrseite des Willens zu physischer und sozialer Aktivität: die Fantasie, statisch, zur Ikone zu werden, im wahrsten Sinn des Wortes Foto zu werden. Doch Lockhart hat in diese Serie einige zögerliche, ja verträumte Posen mit aufgenommen, in denen die Mädchen sich aus dem Prozess der Nachahmung auszuklinken scheinen und sich eher für das interessieren, was um sie herum passiert. Dann drehen sich ihre Basketball-Fantasien nicht mehr um ein Ideal, sondern um die gesellschaftliche Rolle, die sie spielen.

So kehren wir also zurück zu unserem ersten Eindruck von *Goshogaoka*: eine Reihe von Mädchen, die Teil eines gesellschaftlichen Raumes sind, eine Gruppe mit einer gewissen Vertrautheit. Vielleicht muss man die Komplexität von Lockharts 'Kostüm-Dokumentation' einfach im Hinblick auf ihre etymologischen Wurzeln sehen, denn sie beschreibt in der Tat einen Kreis bzw. beschreitet indirekte Wege. Diese mögen impulsiv sein und ein wenig willkürlich erscheinen – es handelt sich ja zuallererst um Kunst –, aber sie ermöglichen eine Auseinandersetzung mit ihrem Gegenstand, die ein direkter Zugriff vielleicht verhindert hätte, eine Auseinandersetzung, die jenen Halt gewährt, den man auf komplizierten Wegen braucht. Natürlich ist hier eine unübersehbare Fingerfertigkeit am Werk, denn die minimalistisch-einfache Schematik in *Goshogaoka* scheint von dieser heiklen Auseinandersetzung ebenso wenig zu verraten wie Lockharts jüngere dokumentationsähnliche Fotos. Dies trifft auch auf die Brasilien-Serie zu, die mit ihrem wissenschaftlich-konzeptuellen Ansatz nichts von den Dimensionen des darin enthaltenen Gefühls verrät. Aber Lockharts Metier ist nun einmal die falsche Fährte und die Genre-Überkreuzung, die aus ihrer Beschäftigung mit dem klinischen Blick hervorgegangen ist und sich im Einsatz kühler, leidenschaftsloser künstlerischer Mittel zur geschickten Erzielung einer affektgeladenen Wirkung fortsetzt.

第51回国民体育大会・続報

１０月１３日から１６日まで、広島県呉市で開催された広島国体。少年準優勝の男子は能代工単独チームの秋田が、女子は名古屋短付を主体とする愛知がインターハイに続く優勝を飾った。今月は、子・山口の活躍ぶりを振り返ってみたい。インターハイ、選抜とはまた違った国体の魅力を彼らは教えてくれた。来年、地元国体を控えている大阪と、男子・大阪と女ムで臨んだ山口。インターハイ、ページでもお伝えしたとおり、男子は能代工単独チームの秋田が、女子は名古屋短付を主体子・山口の活躍ぶりを振り返ってみたい。結果は先月号⑬見事な混成チ

Research material for/Material für *Goshogaoka Girls Basketball Team*, 1997

Goshogaoka Girls Basketball Team:
Yuka Koishihara and Eri Kobayashi;
Yuka Ishigami; Chinatsu Narui and Hitomi
Shibazaki; Kumiko Shirai, 1997
4 framed chromogenic prints/
gerahmte Farb-Negativ-Drucke (detail/Detail)
82.1 x 339.1 cm
courtesy Blum & Poe, Santa Monica

Wie bereits erwähnt, sind *Goshogaoka* und *Goshogaoka Girls Basketball Team* Vorläufer des Brasilien-Projekts. Das sie verbindende Leitmotiv ist die in *Goshogaoka* auf das Bühnenrechteck zentrierte Kamera, ein Motiv, das Lockhart auch in *Teatro Amazonas* verwendet, allerdings in umgekehrter Richtung. Dass in beiden Filmen das Setting dieselbe Rolle spielt, ist nicht zu übersehen. Der zugrunde liegende Amerikanismus in *Goshogaoka* und das Europäertum des *Teatro Amazonas* bilden in Lockharts Projekten jeweils den Ausgangspunkt. Bemerkenswerterweise war es der Regisseur Werner Herzog, der Lockhart auf die Idee brachte, den neuen Film in dem berühmten Opernhaus von Manaus zu drehen. Denn dieses Haus ist Mittelpunkt seines fulminanten Opus Magnum *Fitzcarraldo* (1982), eines Films, der inzwischen zum Symbol geworden ist für die Grenzen einer messianisch-kreativen Vision, und zwar sowohl für den Titelhelden als auch für den Regisseur selbst. Lockharts Beziehung zu dieser Symbolik bleibt unklar, wenngleich sie seit langem eine Vorliebe für den Regie-Film hegt, ebenso wie für Themen und Drehorte, die ihrem Metier eher fremd sind, also für artfremde künstlerische Unternehmungen sozusagen. *Goshogaoka* und *Teatro Amazonas* sind dafür die besten Beispiele. Vor der Planung von *Teatro Amazonas* hatte sie eine Zeit lang daran gedacht, mit einem Ethnographen und einer Anthropologin zusammen zu arbeiten. Als ihre Pläne für den Film dann Gestalt annahmen, kamen die beiden Ideen zusammen und bildeten den Ausgangspunkt für die brasilianische Fotoserie.

Das ursprünglich aus dem Jahr 1896 stammende Opernhaus war mit Hilfe von Geldern aus dem Gummi-Monopol erbaut worden, das ein halbes Jahrhundert lang in dieser Region existierte. Dieses Monopol ist zwar längst erloschen, aber für Lockhart schien die Gummi-Produktion der geeignete Ausgangspunkt ihrer Serie zu sein. Sie nahm Kontakt zu der Anthropologin Ligia Simonian auf, die gerade eine Feldstudie in der Amazonas-Region Rio Aripuanã über die Rolle der Frau in der Gummi-Industrie plante. Außerdem geriet sie zufällig in Kontakt mit Isabel Soares de Souza, die eine Studie über das Tausch-System auf Apeú-Salvador, einer kleinen Insel in der Nähe der Amazonas-Mündung in der Provinz Pará, plante. Dieser Provinz Pará verdankt der Pará-Gummibaum seinen Namen. Er ist übrigens die größte und hochwertigste Quelle für natürliches Gummi in Südamerika. Aus diesen beiden unterschiedlichen Expeditionen ist die Fotoserie

interview locations on the river and the family groups on the island explicitly state this. As it happens, neither of the anthropologists ended up studying what they had intended to study – a common occurrence in field work – both defaulting to secondary aims and projects. Simonian found that the women had a far lesser role in the tapping of rubber than she had believed, and, in fact, the industry had been so decimated by price deregulation that there was little left of it to study. She turned instead to her secondary plan to survey the river region, counting the families and tracking the population, which had been flowing away from the area partly because of the dearth of rubber commerce. De Souza, in the course of her interviews about the island's bartering system with its neighbors, became so sidetracked by a shorter project on genealogical relations among the inhabitants – which was indeed convoluted, for everyone was related – that she spent all her time surveying kinship. Thus, the photograph series' aforementioned elusive, adaptive, opportunistic points of view and overall discursivity are in good measure attributable to the course of the anthropology itself: an effect of the discursive leading the discursive, so to speak.

This is significant on several points. Although one may describe the two groups of photographs along the lines of the respective expeditions, as I just have, Lockhart does not do so in any fashion, except in organizing how they are hung in exhibition and providing terse, though cryptic, credits in her titles. And although one may associate Lockhart's formats with processes of data collection and survey, the anthropological subtext of this work cannot inform us as to the work's aims, for even if we knew it we would know it as yet another question, or problem, or aim deferred. Even the aesthetic of this work – where it is black-and-white, sharply focused, and raw, as in 'old school' social documentary à la Walker Evans – questions the absence of 'text.' Upon first viewing Lockhart's series of interview locations or family groups, one may well recall a body of work such as Evans's Let Us Now Praise Famous Men (1941). The potential parallels with his southern tenant families are many, and the visual connection is compelling. But there is no James Agee lurking behind Lockhart's photograph series, nobody writing the essay, inscribing the meaning. So the meaning does not lie with the anthropologists – they are not even included in any of the pictures – nor in some phantom essay or travelogue; it has not been written

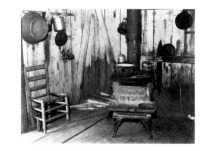

Walker Evans
Alabama Tenant Farmer's Kitchen Near Moundville/[Kitchen of Bud Fields' (Bud Woods) Home, Hale County, Alabama], 1936
gelatin silver print/Gelatine-Silber-Druck
19.2 x 24.2 cm
courtesy The J. Paul Getty Museum, Los Angeles

On Kawara: Whole and Parts, 1964-95
Museum of Contemporary Art Tokyo
January 24 - April 5, 1998, 1998
4 framed chromogenic prints/
gerahmte Farb-Negativ-Drucke
163.8 x 619.8 cm
courtesy Blum & Poe, Santa Monica

Enrique Nava Enedina: Oaxacan Exhibit Hall, National Museum of Anthropology, Mexico City, 1999
3 framed chromgenic prints/
gerahmte Farb-Negativ-Drucke
127 x 552.5 cm
courtesy Blum & Poe, Santa Monica

hervorgegangen; sie lässt sich in zwei Gruppen unterteilen: Fluss-Aufnahmen und Fotografien von Inseln. Sie sind von ganz unterschiedlichem Charakter. Die Fluss-Serie entstand innerhalb von siebzehn Tagen und ist naturgemäß eher linear nach ihrem zeitlichen Ablauf angelegt, denn sie entstand im Laufe einer Bootsfahrt von Dorf zu Dorf den Fluss hinauf und hinunter. Bei jedem Halt interviewte die Anthropologin eine oder mehrere Familien in der gewohnten Umgebung ihrer Behausung. Lockhart und der Kameramann sassen dabei. Anschließend fotografierte Lockhart den leeren Ort des Interviews sowie einige Schnappschüsse aus dem Familienalbum. Angesichts der leeren Interview-Orte und der reproduzierten Schnappschüsse ist die Fluss-Serie auch die indirektere der beiden Serien. Die Insel-Fotos hingegen zeigen die menschlichen Figuren verhältnismäßig direkt und sind weder linear angelegt noch spiegelt sich in ihnen ein zeitlicher Ablauf. Alle Fotos entstanden während eines einzigen Aufenthalts. Lockhart machte auf der kleinen Insel zwar zahlreiche Aufnahmen und durchquerte, wie das eben zum Inselleben gehört, immer wieder dasselbe Gebiet, aber da sie sich entschied, nur Inselbewohner in ihre Serie aufzunehmen, hat diese eher Porträt-Charakter.

Die auffälligste Gemeinsamkeit zwischen den beiden Serien ist die dokumentarische Struktur, die ein bestimmtes Muster ergibt und den Eindruck erweckt, es sei dabei um eine Datenerhebung oder eine 'Vermessung' gegangen. Und tatsächlich legen die Bezeichnungen der Interview-Orte am Fluss und der Familiengruppen auf der Insel dies ausdrücklich nahe. Letztendlich studierte keine der Anthropologinnen das, was er eigentlich studieren wollte – was bei Feldstudien keineswegs ungewöhnlich ist -, so dass weder die sekundären Absichten noch die Projekte selbst realisiert werden konnten. Simonian stellte fest, dass die Frauen bei der Gummi-Gewinnung eine weit geringere Rolle spielten, als sie vermutet hatte. In der Tat war die Industrie durch den freien Markt so sehr zurückgegangen, dass es kaum noch etwas zu studieren gab. Stattdessen besann sie sich auf ihren zweiten Plan, eine Bestandsaufnahme der Flussregion. Sie zählte die Familien und verfolgte die Migrationsbewegungen der Population, die teilweise aus dem Gebiet abgewandert war, weil der Gummi-Handel nicht genug abwarf. De Souza unterdessen widmete sich im Laufe ihrer Interviews über den Tauschhandel der Inselbewohner mit ihren Nachbarn einem kleineren

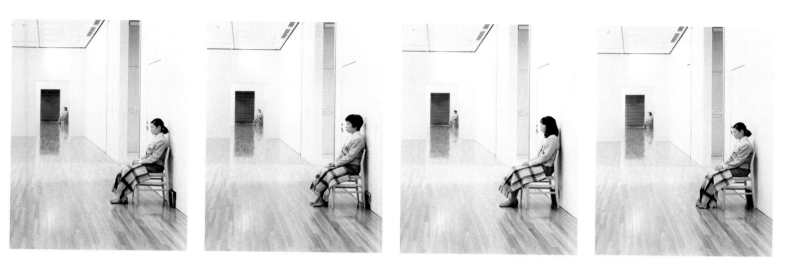

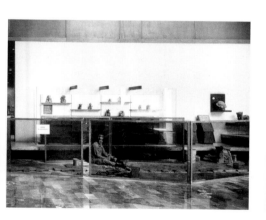
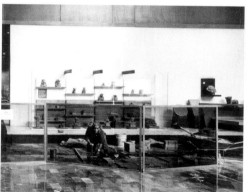
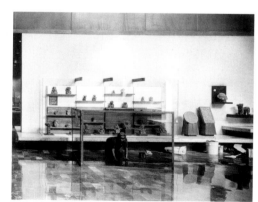

by Lockhart or anyone else. Rather, the meaning lies, or partly lies, in between virtual 'texts' and the actual images, and thus can in some ways be specified and in some ways not.

Lockhart's documentary-style work may be best characterized by how it follows what it follows in two key senses of the word. One of these is particularly relevant to any kind of documentary: to follow as to attend to (something) closely. Of course, this is what a camera is quite able to do, and what Lockhart to an extent has done in working with the anthropologists and their subjects. The other has to do with one's relation to what has preceded: to follow as to come after (something). In art, where one is always following something in this sense, even when breaking new ground or hybridizing, how one does it is significant. A few of Lockhart's recent photograph series are illuminating in this respect and translatable to the unique conditions of the Brazilian series. *On Kawara: Whole and Parts* (1998), a quartet of photographs documenting the rotations of museum security at an On Kawara exhibition in Tokyo, obviously attends to its subject closely, for the work detail and the human detail are more than adequately conveyed. It also brings to bear a virtual text of conceptualism, as it refers to Kawara, one of conceptualism's forerunners, but does so only through supplemental text (the title), a cliché trope of conceptual art. Although it emulates, as well as refers to, Kawara in the temporality of the series and the cyclical nature of the occupation itself, it is the female guards in whom the camera is most interested. One anomalous detail in particular commands the pictures: the blankets draped over the laps of the seated women, a touch point of domesticity and comfort in the frozen environs of the institution.

Enrique Nava Enedina and *Chronicle of Masonry Work* (both 1999) constitute a more thoroughgoing documentation of labor – the repair of stone floors at the National Museum of Anthropology in Mexico City – taking the institution as its primary frame of reference – again, an implicit motif of conceptualism (*pace* Benjamin H. D. Buchloh). Indeed, the virtual text of these photographs is quite thoroughgoing as well, for we see Enrique working in the present, as well as various sites, in which he does not appear, of long-since completed and not-yet-begun repair work within the museum. Yet the thrust of these devices pales in comparison to the pathos in the images of Enrique laboring in the ever-contracting glass cage separating his work area from public space: an exhibit

Projekt über die genealogischen Beziehungen der Bewohner untereinander. Dies erwies sich als kompliziert, weil jeder mit jedem verwandt war. So verbrachte sie ihre ganze Zeit damit, Verwandtschaftsverhältnissen nachzuspüren. Der zuvor erwähnte flüchtige Charakter der Fotoserie, die von der Situation abhängigen und aus ihr heraus entwickelten Standpunkte sowie die umfassende Diskursivität sind also zu einem guten Teil Ergebnis der Anthropologie. Der Diskurs führt sozusagen zum Diskurs.

Dies wird an verschiedenen Punkten deutlich. Zwar kann man die beiden fotografischen Gruppen anhand des jeweiligen Expeditions-Verlaufs beschreiben, wie ich es gerade getan habe, doch Lockhart geht, außer bei der Hängung und bei den knappen, aber kryptischen Angaben in den Titeln, anders vor. Und obwohl Lockharts Strukturen an Datenerhebungen oder Vermessungen erinnern, verrät uns der anthropologische Hintergrund der Arbeit nichts über deren Ziel. Denn auch wenn wir es kennen würden, wäre es nichts als eine Frage oder ein Problem, ein Ziel, das anderswo zu finden ist. Selbst die Ästhetik dieses Werks lässt – beispielsweise in den exakt fokussierten, roh wirkenden Schwarzweiß-Aufnahmen, die an die soziale Documentar-Fotografie 'alter Schule' à la Walker Evans erinnern – die Abwesenheit von 'Text' fraglich erscheinen. Auf den ersten Blick mag man bei Lockharts Serie der Interview-Orte oder Familien-Bilder durchaus an eine Werkgruppe wie Evans' *Let Us Now Praise Famous Men* (1941) denken. Es gibt zahlreiche Parallelen zu seinen Farmer-Familien aus dem Süden, und die visuellen Berührungspunkte sind verblüffend. Aber hinter Lockharts Fotoserie lauert kein James Agee, niemand, der einen Aufsatz schreibt und Bedeutung hineininterpretiert. Die Bedeutung liegt also nicht bei den Anthropologinnen – sie kommen in keinem der Bilder vor –, und sie verbirgt sich auch nicht in irgendeinem geheimnisvollen Aufsatz oder Reisebericht. Weder Lockhart noch sonst jemand hat sie in Worte gefasst. Die Bedeutung ist eher – zumindest teilweise – zwischen virtuellen 'Texten' und den eigentlichen Bildern angesiedelt. Deshalb lässt sie sich manchmal fassen, und manchmal eben nicht.

Lockharts Arbeit im dokumentarischen Stil lässt sich am besten durch die Art charakterisieren, wie sie das verfolgt, was sie verfolgt – im doppelten Sinn des Wortes. Da ist zum einen das, was bei jeder Art von Dokumentation gilt: (etwas) genau ins Auge fassen und verfolgen. Diese Aufgabe erfüllt natürlich vor

of indigenous human labor within an exhibit of indigenous cultural artifacts.

In each of these works Lockhart follows conceptualism (or postconceptualism) in the sense of coming after and to an extent emulating it, but she does not attend to it closely by taking up its arguments. It, too, becomes instead a virtual text of the work. As such, it informs and frames the image, opens possibilities of meanings, but does not define it. Each of these works attends to its human subject very closely – though in quite different ways, given the unusually thematic treatment of *Enrique*. Yet it is inadequate to say that this is where the meaning lies, for it has been framed as such and cannot be separated from this framing. Meaning, then, lies somewhere in between. Nowhere is this made more plain than in the Brazilian series, where anthropology (scientism) becomes the virtual text informing or framing the photographic schema, but not defining the images per se. In effect, as with the role of the clinical in Lockhart's earlier work, it becomes the tacit, though unelaborated, structure of inquiry that permits the in-between place of her free and close looking. Consider the river photographs, with their vacated interview locations and rephotographed snapshots. An incredible tension surrounds the 'absent' human subject, for the work locates itself in between an intensely detailed perspective of the family's material surroundings and habiliments and an almost excruciating glimpse into its sentimental interior. The conditions of living, which in this region are quite austere, are boiled down to the some of the most basic parameters of existence and circumstance: regional politics (literally, political wallpaper), media acculturation (more wallpaper in the form of newspaper and magazine clippings), material desire (advertisements with images of glittering things, safely positioned objects of value and status such as stereo radios and the car batteries to power them), family and self (desultory portraits interspersed with the above). In all of these images, the rephotographed snapshots especially, we see the uncanny close distance of Lockhart's practice, and the discursiveness within its formal patterning. For with the permission of an 'objective' gaze, she does what she has so often done, which is to fuse it with a gaze of affection.

The island photographs expand on this, though they take a different route. Here, living is less austere, with ample food and a stable trade economy. In part because of this more fortunate condition, Lockhart chooses to focus on the inhabitants directly,

allem die Kamera und in gewissem Maß ja auch Lockhart selbst, wenn sie mit den Anthropologinnen und deren Beobachtungsgegenständen arbeitet. Zum anderen geht es aber um die Beziehung zu etwas Vorangegangenem: (auf etwas) folgen. In der Kunst, wo man immer die Folge von irgend etwas antritt, selbst wenn man neues oder fremdes Terrain betritt, ist es entscheidend, wie man es macht. Einige von Lockharts jüngsten Fotoserien werfen ein erhellendes Licht auf die einzigartigen Bedingungen der Brasilien-Serie. *On Kawara: Whole and Parts* (1998), vier Fotos, die den Wechsel der Museumaufsicht in einer Tokioer On Kawara-Ausstellung dokumentieren, beobachten ihren Gegenstand offensichtlich ganz genau, denn künstlerische wie menschliche Details sind überaus präzise wiedergegeben. Auch ein virtueller Zusammenhang mit dem Konzeptualismus kommt zum Tragen, weil auf On Kawara Bezug genommen wird, einen der Vorreiter des Konzeptualismus, allerdings nur durch den ergänzenden Text (den Titel), eine typisch konzeptualistische Methode. Zwar bezieht sich die Arbeit quasi imitierend auf On Kawara, indem sie einen zeitlichen Ablauf in zyklischer Form festhält, zugleich interessiert die Kamera sich aber vor allem für die weiblichen Aufseher. Besonders ein ungewöhnliches Detail beherrscht die Bilder: die Decken, die sich die Frauen im Sitzen über den Schoß gelegt haben, ein Anklang von Häuslichkeit und Gemütlichkeit in der unterkühlten Umgebung des Museums.

Enrique Nava Enedina und *Chronicle of Masonry Work* (beide 1999) sind tiefblickende Dokumentationen von Arbeit – Reparaturarbeiten an den Steinböden des National-Museum für Anthropologie in Mexico City – und präsentieren die Institution als ihren wichtigsten Bezugsrahmen. Auch hier haben wir es implizit wieder mit einem konzeptualistischen Motiv zu tun (ohne Benjamin H.D. Buchloh nahetreten zu wollen). Auch der virtuelle Text der Fotos ist sehr tiefgründig, denn wir sehen einmal Enrique bei gegenwärtigen Arbeiten, dann aber auch zahlreiche Orte im Museum, an denen er nicht in Erscheinung tritt. Dort wurden Reparaturen bereits abgeschlossen oder noch nicht begonnen. Doch die Kraft dieser Mittel ist nichts im Vergleich zum Pathos jener Bilder, die Enrique in der Enge eines Glaskäfigs zeigen, der seinen Arbeitsbereich vom öffentlichen Museumsbereich trennt: die Zurschaustellung einheimischer menschlicher Arbeit im Rahmen der Zurschaustellung von Artefakten einheimischer Kultur.

minimizing the episodic survey format of the river series in favor of one more influenced by the ethnographic 'direct cinema' of Rouch. Of course, Rouch's cinema is anything but direct from the point of view of data collection, though profoundly direct with respect to his interaction with his human subject. For it is a shared or participatory documentary cinema in which the subject is full partner in his or her own representation. Rouch himself had rejected the 'comfortable sort of incognito' behind which the ethnographic filmmaker hides himself, whether out of scientism or ideological shame, and was confident in the efficacy of 'staging reality' or basing documentary on the 'companionship' between filmmaker and subject – a conviction he came to hold, interestingly, through his admiration for Robert Flaherty's 1922 *Nanook of the North*. His influence on Lockhart's practice, evident in the 'costume documentary' of *Goshogaoka* and elsewhere, though more subtly, is here keyed on the idea of participation and shared representation. This is clearly discernible in the multiple poses of the family group photographs, which are in part self-portraits.

After gathering the family together and talking over the general plan, she would ask them to select the location for the photograph, which in most cases became the common room of the dwelling. She would then ask for the first pose and shoot it, along with a Polaroid. They would then examine the picture and rearrange themselves for the next pose if they desired, and the process would repeat again, two times more. The Polaroids were all left with the families – a Rouchian 'counter-gift,' one might say. Some of these portraits are delightful and lively, some fairly bland, depending on the character of each family group: the relative sternness of the matriarch or patriarch, the general level of obedience or patience among the children, the irrepressible singular personality or irremediably self-conscious one, and, to be sure, the untold unknowable. The engagement of these characteristics through a combination of choice and accident is the strength of this work, for, unlike the river photographs, the human interior is seen here as a dynamic representation, as well as a static and material one. Yet, almost perversely, it is the series of Maria da Conceição Pereira de Souza holding the fruits of the island that becomes most emblematic of the island photographs and, perhaps, with *Teatro Amazonas*, the Brazilian project as a whole. For in these images the gaze of objectivity and affection are co-present with such clarity and

In jeder dieser Arbeiten folgt Lockhart insofern einem konzeptualistischen (bzw. postkonzeptualistischen) Prinzip, als sie erstens in dessen zeitlicher Nachfolge steht und es zweitens gewissermaßen nachahmt. Zugleich aber geht sie auf Distanz dazu, weil sie sich nicht an die konzeptualistische Argumentationsweise hält. Vielmehr wird auch diese zu einem virtuellen Text der Arbeit. Als solcher prägt der Text das Bild, eröffnet mögliche Bedeutungen, legt es aber nicht fest. Jede einzelne Arbeit ist unmittelbar auf ihren menschlichen Gegenstand bezogen, wenngleich auch jeweils ganz unterschiedlich, was an der ungewöhnlichen Thematik von *Enrique* liegt. Dennoch lässt sich auch daran keine Bedeutung festmachen, weil das Werk in seinem speziellen Rahmen daherkommt und nicht losgelöst davon zu sehen ist. Die Bedeutung liegt vielmehr irgendwo dazwischen. Nirgendwo tritt dies klarer zutage als in der Brasilien-Serie, wo die Anthropologie (die Wissenschaft) als virtueller Text das fotografische Schema zwar prägt, nicht aber den Inhalt der Bilder selbst bestimmt. Vergleichbar der Rolle des klinischen Blicks in Lockharts früherem Werk ist es hier die stillschweigende, aber nicht weiter ausgeprägte Struktur der Befragung, die es ihr erlaubt, aus einer Zwischenposition ebenso ungeniert wie genau hinzusehen. Denken wir an die Fluss-Fotos mit ihren verlassenen Interview-Orten und reproduzierten Schnappschüssen. Eine unglaubliche Spannung geht von dem 'abwesenden' menschlichen Gegenstand aus, weil uns das Werk einen intensiv-detailreichen Blick auf die materielle Ausstattung und Kleidung der Familie sowie einen fast erschreckenden Einblick in deren Gefühlsleben gibt. Die in dieser Region sehr kargen Lebensbedingungen sind auf einige grundlegende Parameter der Existenz und ihrer Umstände reduziert: Regionalpolitik (politische Tapete im wahrsten Sinn des Wortes), Präsenz der Medien (noch mehr Tapete in Form von Zeitungen und Ausrissen aus Zeitschriften), materielle Wünsche (Werbebilder von glitzernden Dingen, sicher aufbewahrte Wertgegenstände und Statussymbole, wie beispielsweise Radios und die Autobatterien, mit denen sie betrieben werden), Familie und Ich (Porträts, zwischen den erwähnten Gegenständen verstreut). In all diesen Bildern, vor allem aber den abfotografierten Schnappschüssen, begegnen wir der unheimlichen Nähe in Lockharts Praxis sowie der Diskursivität innerhalb ihrer formalen Struktur. Denn indem sie einen 'objektiven' Blick gewährt, führt sie, wie schon so oft, zugleich eine höchst emotionale Sichtweise ein.

alance that they reach a kind of stalemate, a termi-
us of incommensurability. With color and a degree
f sensuality a world apart from any of the other
hotographs, the images render their dual subject in
he flesh, thus amplifying the anxiousness in the
meeting of incommensurable scopic drives: the drive
o survey, document, or classify and the drive to look
losely at a human subject. In Maria's subtly chang-
ng, though irrepressible, expression, however, is the
uggestion that, perhaps, all is right and good here –
r just good, for right does not matter. In her face, as
n her hands, we see the fruit of island culture and are
almed by it. Thus, the punctuation this series brings
o Lockhart's project is, in the end, ambivalently
ronounced, like a question mark in parentheses.

 With Herzog at one end and Rouch at the other,
he Brazilian project presents quite a conundrum to
hose of us trying to understand Lockhart's practice.
Ve know that her far-flung enterprise has aims for
he in between, but what sort of in between is there
etween Herzog and Rouch? Herzog, whose most
ssential and consistent modality is self-estrange-
nent, ventures into jungles and deserts, not merely
o test the will of his main characters or his own,
ut to work through problems of being existentially,
istorically, and terminally European. Rouch brings
uropean technique to the problem of representing
he indigenous Other, and discovers that through
ollaboration and companionship his work can be
nstrumental in his subject's self-imaging and defini-
ion. How can these two coexist in Lockhart's prac-
ice or, for that matter, that of any other artist? And
ow does bringing structural film and monotonic
nusical composition to the Amazon or 'minimal'
ance and 'costume documentary' to rural Japan fac-
or in such a question? I, for one, am not sure, exact-
y, but appreciate the inscrutability of the practice
hat poses the question to me. It is certain, however,
hat documentary, as Lockhart has employed it, has
nuch to do with how difficult the question becomes,
or it raises the stakes of the representation of her
uman subject. Bearing this in mind, one might
implify the question: to whom is she closest, Herzog
r Rouch? To this, I must default to an assumption
 have about Lockhart personally, that she is an artist
rimarily interested in people, and let Rouch have
he last word:

 Why and for whom do we put the camera
 amongst people? Strangely enough, my first
 response will always be the same: 'For myself.' It
 isn't that I'm addicted to a particular drug whose

Die Insel-Fotografien bedienen sich dieser Methode
in noch größerem Maß, gehen dabei aber einen
anderen Weg. Das Leben ist hier nicht so hart, es gibt
ausreichend Nahrung und eine stabile Wirtschaft.
Auch auf Grund dieser angenehmeren Lebens-
situation wählt Lockhart einen direkteren Blick auf
die Bewohner, so dass der aus Episoden zusammen-
gefügte Überblick der Fluss-Fotos einer Struktur
weicht, die sich an Rouchs ethnografisches 'direktes
Kino' anlehnt. Rouchs Kino ist vom Standpunkt der
Datenerhebung aus gesehen natürlich alles andere
als direkt. Aber seine Auseinandersetzung mit dem
Menschen ist dennoch ganz unmittelbar. Denn es ist
ein auf Gegenseitigkeit beruhendes, partizipatorisch-
dokumentarisches Kino, in dem das Gegenüber bei
seiner bzw. ihrer Darstellung eine partnerschaftliche
Rolle übernimmt. Rouch selbst hat auf das 'bequeme
Incognito' verzichtet, hinter dem sich der ethno-
graphische Filmemacher versteckt, sei es aus wissen-
schaftlichem oder aus ideologischem Schamgefühl.
Stattdessen vertraute er darauf, 'die Wirklichkeit vor
die Kamera zu bringen'. Bei ihm basierte der doku-
mentarische Charakter auf der 'Gemeinschaft' von
Filmemacher und gefilmter Person. Interessanter-
weise kam er zu dieser Haltung durch seine
Bewunderung für Robert Flahertys *Nanook of the
North* aus dem Jahre 1922. Sein Einfluss auf Lockharts
Praxis, der sich in subtilerer Form in der 'Kostüm-
Dokumentation' von *Goshogaoka* und anderswo nie-
derschlug, kommt hier in der Idee der Partizipation
und der gemeinsam bestimmten Darstellung zum
Ausdruck. Deutlich erkennbar ist dies an den vielen
verschiedenen Posen auf den Familiengruppenfotos,
die in gewisser Hinsicht Selbstporträts sind.

 Nachdem sie die Familie um sich versammelt und
mit ihr den allgemeinen Plan durchgesprochen hatte,
bat Lockhart sie, den Ort für das Foto auszusuchen.
Meist entschied sich die Familie für das gemeinsame
Wohnzimmer. Dann forderte sie die Gruppe auf,
sich in Pose zu bringen und fotografierte sie.
Zugleich fertigte sie auch eine Polaroid-Aufnahme
an. Dann sahen sie sich das Bild an und gruppierten
sich je nach Wunsch neu. Der Vorgang wurde zwei-
mal wiederholt. Die Polaroids blieben bei der Familie
– als Rouch'sche Gegengabe sozusagen. Einige dieser
Porträts sind wunderbar lebendig, andere ziemlich
nichtssagend, je nach Charakter der Familiengruppe.
Das hing zum Beispiel davon ab, wie streng das –
männliche oder weibliche – Familienoberhaupt war,
ob die Kinder gehorsam oder geduldig waren,
wie sehr sich einzelne Personen in den Vordergrund

'lack' would make itself quite regularly felt, but
rather that, at certain times in certain places and
around certain people, the camera […] seems to
be necessary.'

Notes

1.
Jean Rouch, 'The Camera and Man (Extract),' in
Mick Eaton, ed., *Anthropology-Reality-Cinema: The
Films of Jean Rouch* (London: British Film Institute,
1979), p. 61.

spielten; vor allem aber hing es natürlich auch vom
unausgesprochenen Unbekannten ab. In der
Kombination aus bewusster Entscheidung und Zu
liegt die Stärke dieser Arbeit, denn im Gegensatz
den Fluss-Fotos wird der Wohnraum der Mensche
hier als dynamische ebenso wie als statische und
materielle Selbstdarstellung verstanden. Doch ver
blüffenderweise ist gerade die Serie, in der Maria
Conceição Pereira de Souza Früchte der Insel
präsentiert besonders typisch für die Insel-Fotos u
– zusammen mit *Teatro Amazonas* – für das
Brasilien-Projekt überhaupt. Denn in diesen Bilde
stehen Objektivität und emotionale Zuwendung i
solch vollkommener Balance und Klarheit nebene
ander, dass sich eine Art Pattsituation ergibt, ein
absolut unvergleichlicher Zustand. Mit ihrer Farbi
keit und einem gewissen Maß an Sinnlichkeit stell
diese Fotos eine Welt jenseits aller anderen Foto-
grafien her und geben ihren zweifachen Gegensta
quasi in natura wieder. Im Aufeinandertreffen unt
schiedlichster Antriebe erhöhen sie die Spannung
zwischen dem Drang, etwas zu vermessen, zu dok
mentieren oder zu klassifizieren einerseits und de
Wunsch, ein menschliches Gegenüber aus großer
Nähe zu betrachten andererseits. In Marias kaum
merklich wechselndem, gleichwohl unbezähmbar
Ausdruck liegt jedoch vielleicht die Vorstellung, d
alles hier richtig und gut ist – oder nur gut, denn ri
tig spielt keine Rolle. In ihrem Gesicht wie in ihren
Händen sehen wir die Früchte der Inselkultur und
sind beruhigt. Doch das Zeichen, das diese Serie i
Lockharts Projekt setzt, ist letztlich ambivalent,
wie ein Fragezeichen in Klammern.

Mit Herzog auf der einen und Rouch auf der
anderen Seite birgt das Brasilien-Projekt für jene,
die Lockharts Arbeitsweise zu verstehen suchen, e
großes Rätsel. Wir wissen, dass ihr breit angelegte
Unterfangen auf das 'Dazwischen' zielt, aber was
ein Dazwischen gibt es zwischen Herzog und
Rouch? Herzog, dessen wichtigstes und durchgän
gigstes Mittel die Selbstentfremdung ist, dringt in
Dschungel und Wüsten vor, nicht nur um den Dur
haltewillen seiner Hauptdarsteller oder seinen eig
nen zu testen, sondern um auf diese Weise die
Problematik eines existentiellen, historischen und
terminologischen Europäertums zu erforschen.
Rouch nähert sich mit europäischer Technik dem
Problem, das einheimische Andere darzustellen u
entdeckt, dass seine Arbeit durch Mitwirkung und
gemeinsame Entscheidungen zu einem Instrumen
für sein Gegenüber wird, mit dessen Hilfe er oder

sich selbst definieren und sich von sich selbst ein Bild machen kann. Wie aber können diese beiden Methoden in Lockharts Praxis – oder der irgendeines anderen Künstlers – zusammen wirken? Und welche Rolle spielt es in diesem Zusammenhang, wenn man den strukturellen Film und monotone Musik zum Amazonas bringt oder 'Minimal'-Tanz und 'Kostüm-Dokumentationen' ins ländliche Japan? Ich für meinen Teil weiß keine Antwort, aber ich schätze die Unergründlichkeit einer Tätigkeit, die mir eine solche Frage stellt. Ohne Zweifel liegt es aber an der Art, wie Lockhart das Dokumentarische angeht, dass die Frage so schwer zu beantworten ist, denn es geht um die Grundfragen der Menschen-Darstellung. So kann man die Frage vielleicht einfacher stellen: Wem steht sie näher, Herzog oder Rouch? An dieser Stelle muss ich eine persönliche Vermutung über Lockhart äussern, nämlich dass sie eine Künstlerin ist, die sich vor allem für Menschen interessiert. Und in diesem Sinne überlasse ich Rouch das letzte Wort:

> Warum und für wen stellen wir die Kamera zwischen die Leute? Seltsamerweise bleibt meine erste Antwort immer dieselbe: 'Für mich selbst.' Es handelt sich dabei aber nicht um eine Droge, deren 'Entzug' sich regelmäßig bemerkbar machte; vielmehr scheint zu gewissen Zeiten an gewissen Orten mit gewissen Menschen die Kamera (…) einfach zwingend notwendig zu sein.[1]

Anmerkungen

1.

Jean Rouch, 'The Camera and Man (Extract)', in Mick Eaton, Hrsg., *Anthropology-Reality-Cinema: The Films of Jean Rouch* (London, British Film Institute, 1979), S. 61.

Ekko von Schwichin
Photograph of/Foto von Jean Rouch

Aripuanã River Region: Interview Locations /
Aripuanã-Region: Interview-Orte

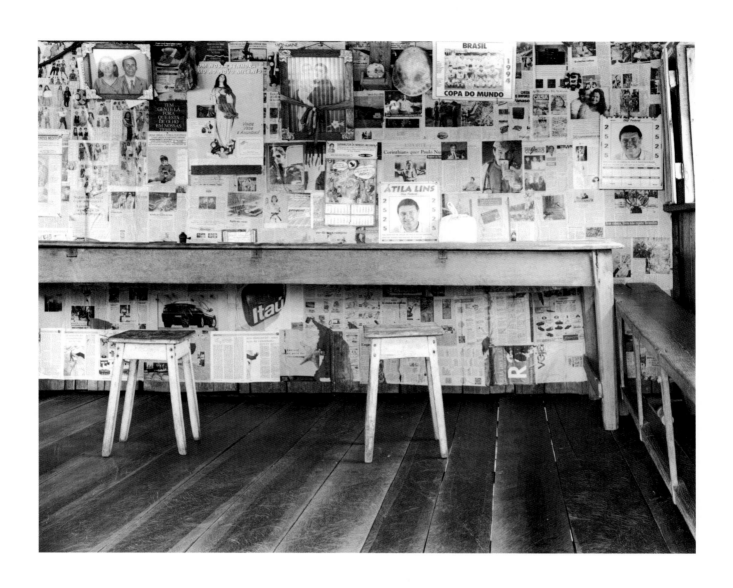

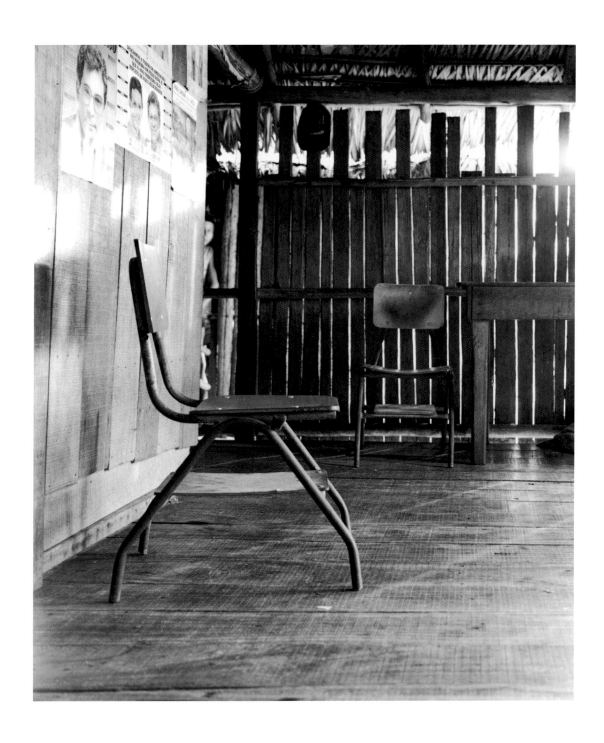

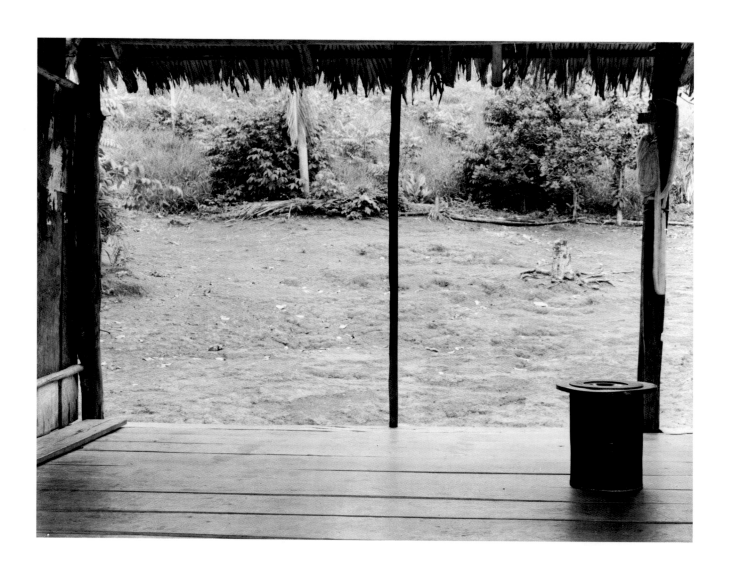

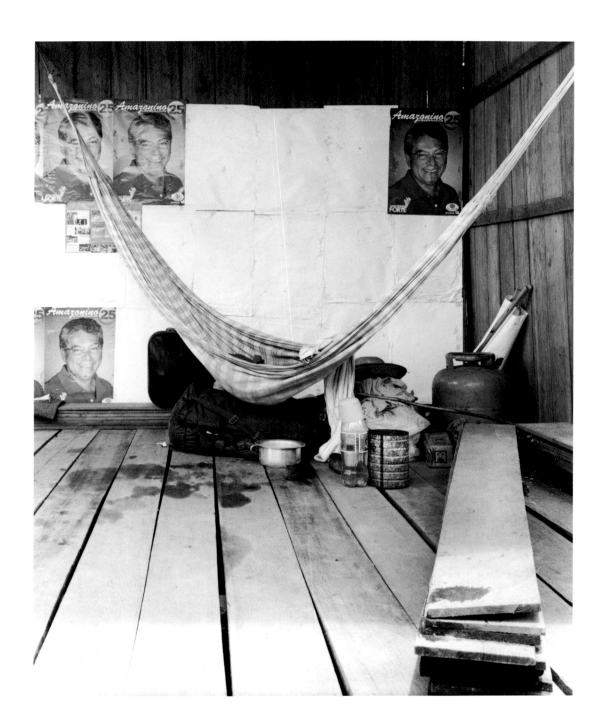

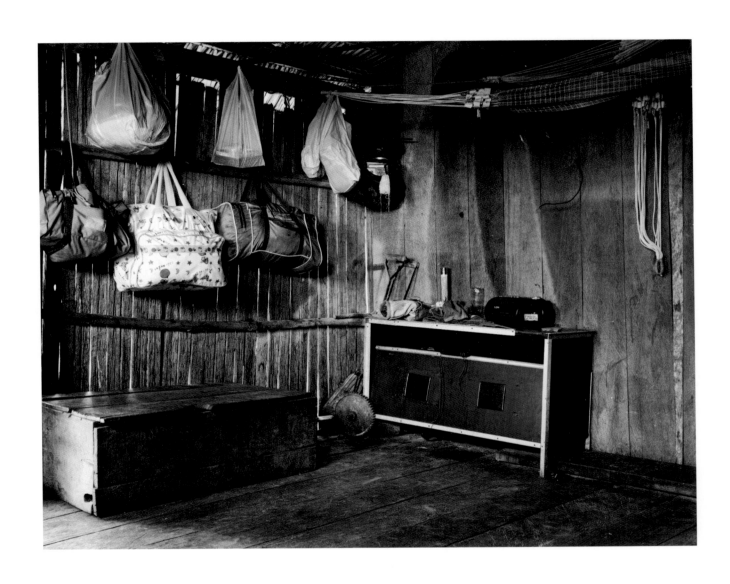

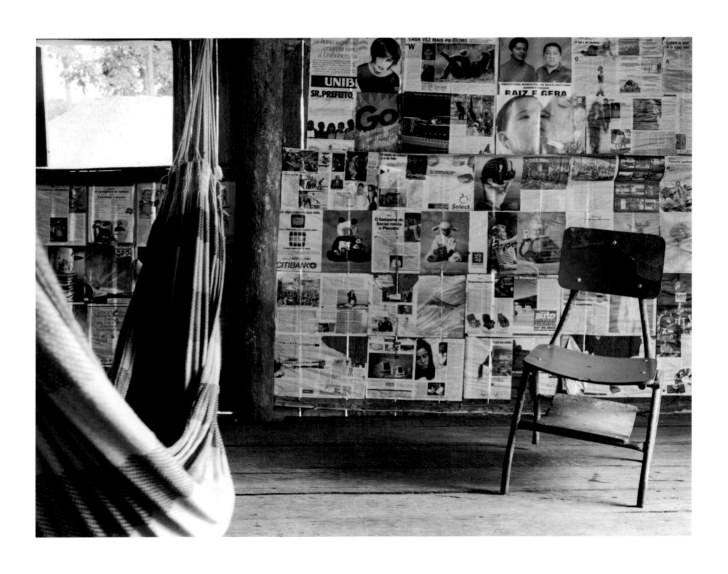

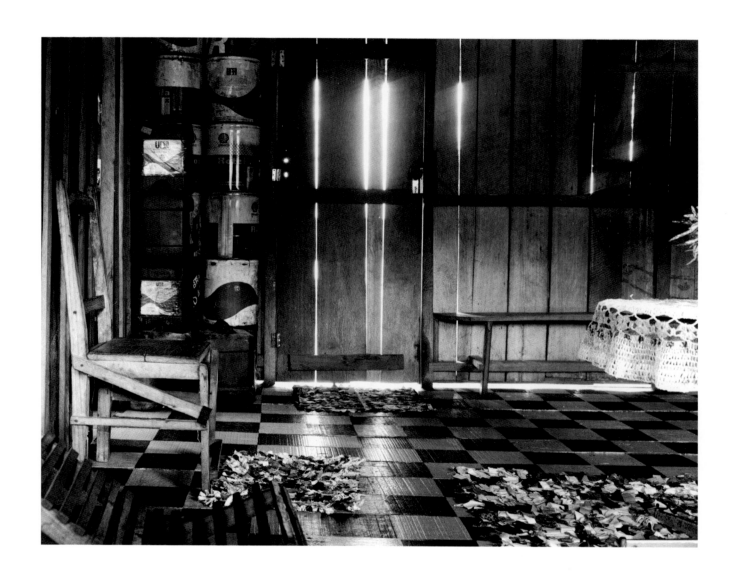

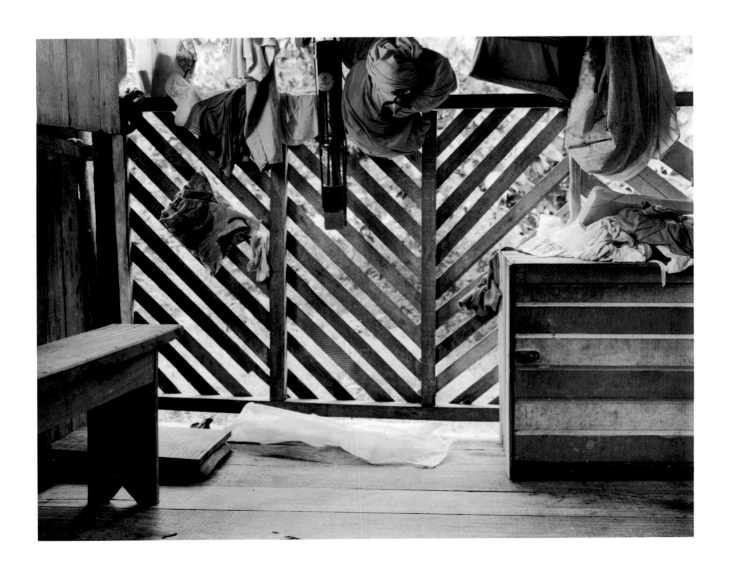

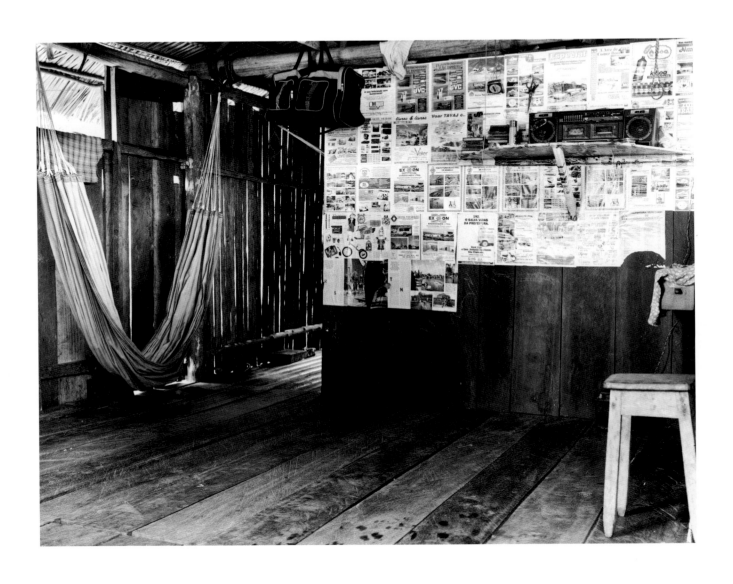

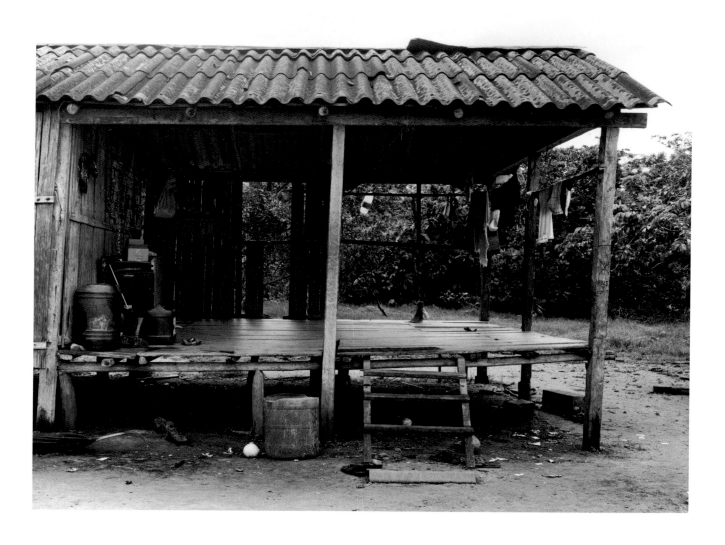

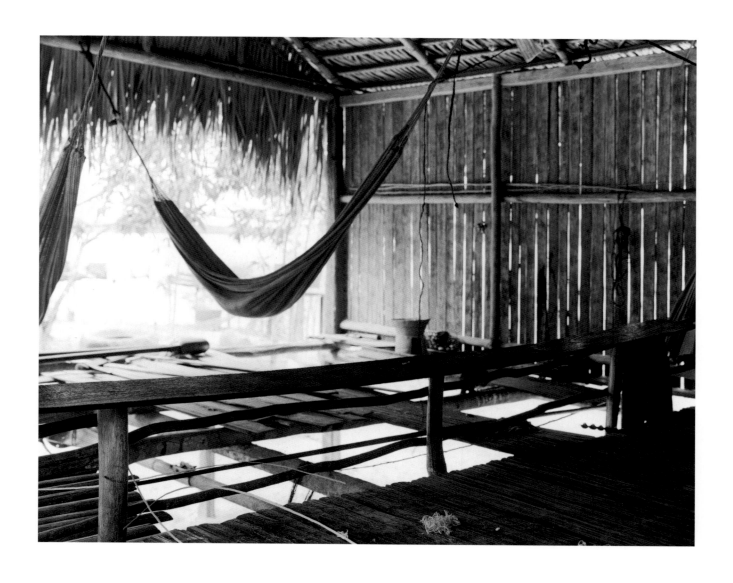

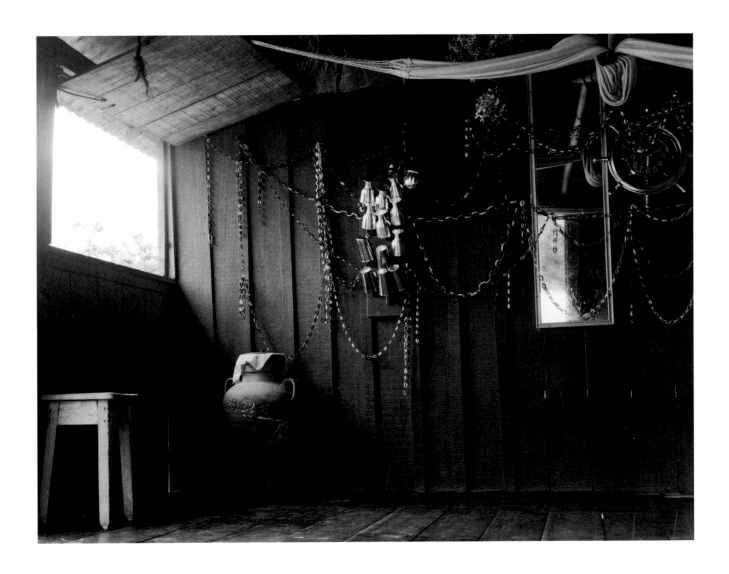

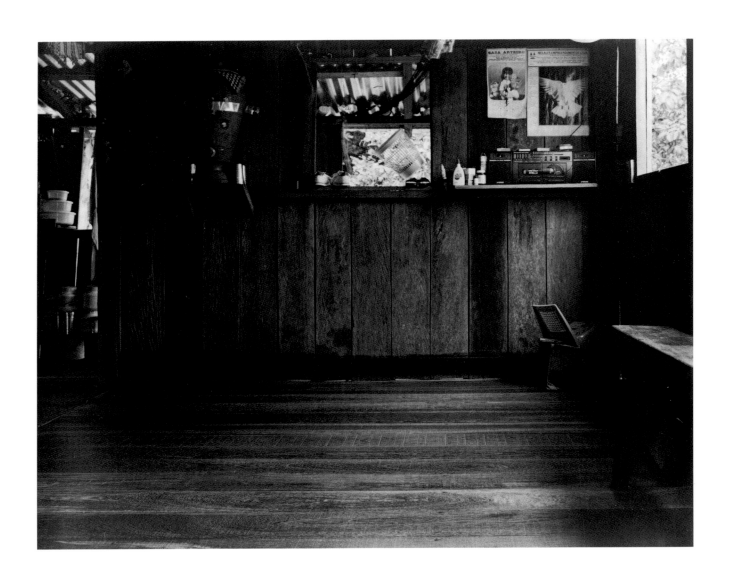

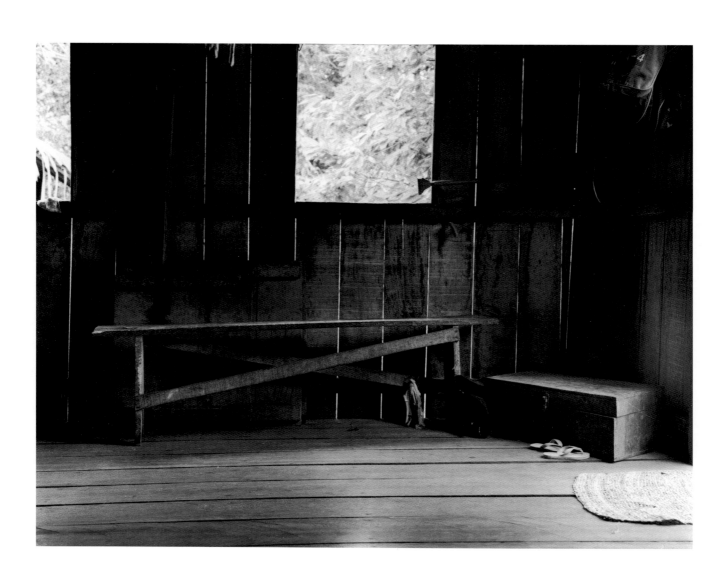

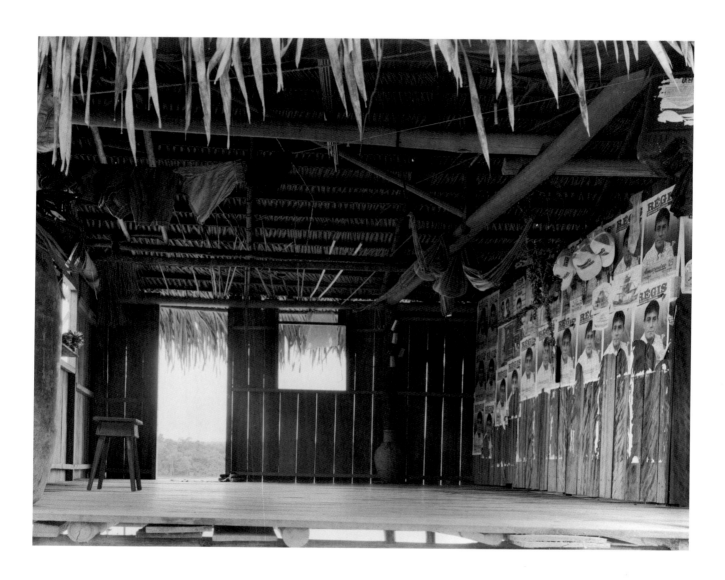

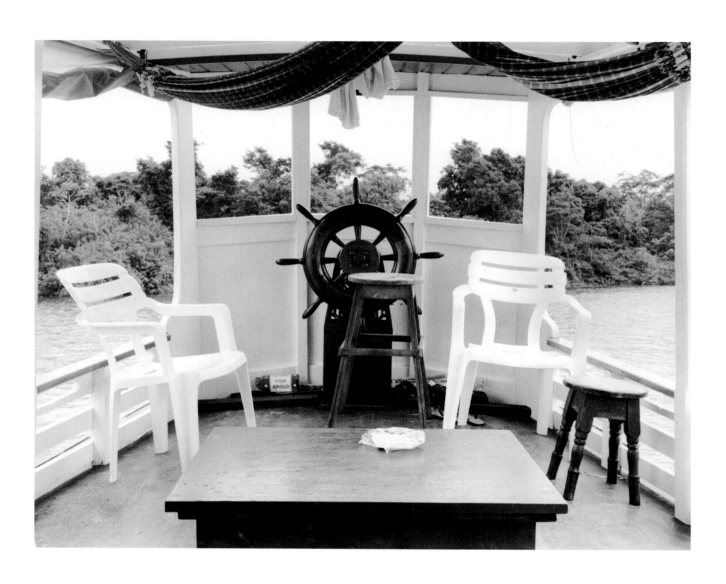

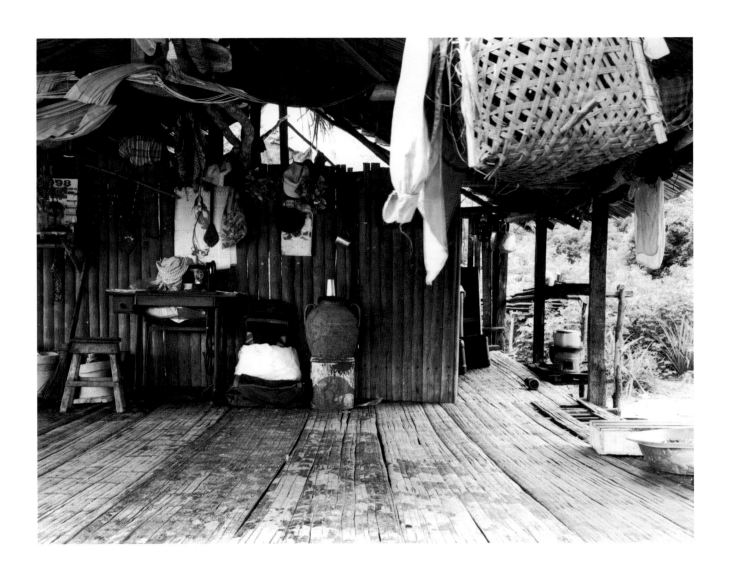

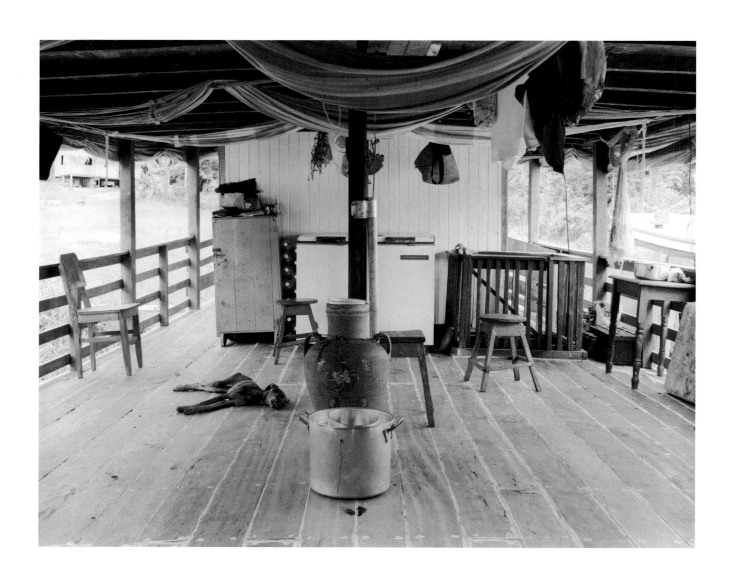

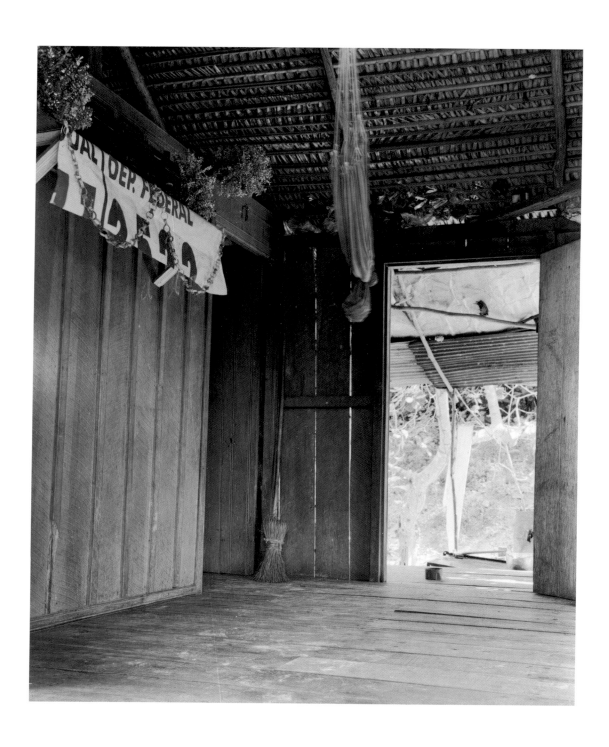

Aripuanã River Region: Family Photographs /
Aripuanã-Region: Familien-Fotos

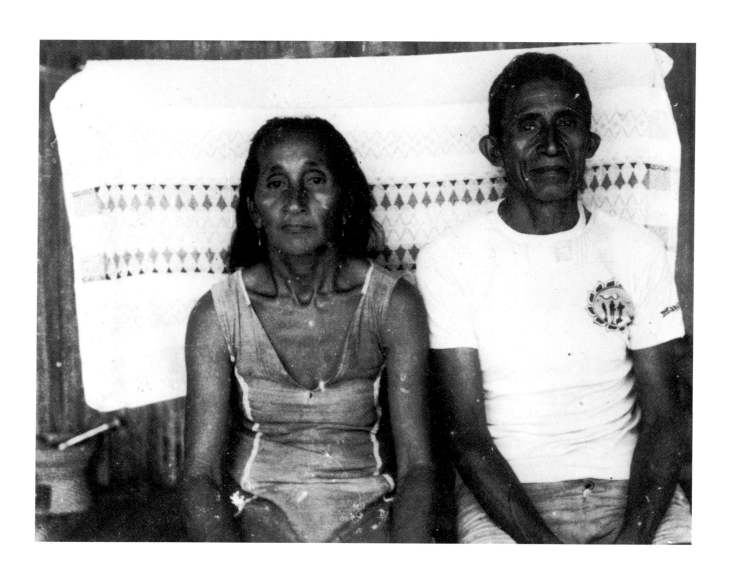

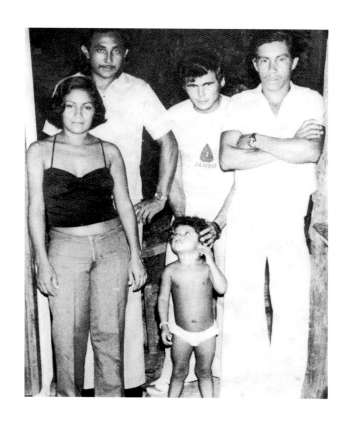

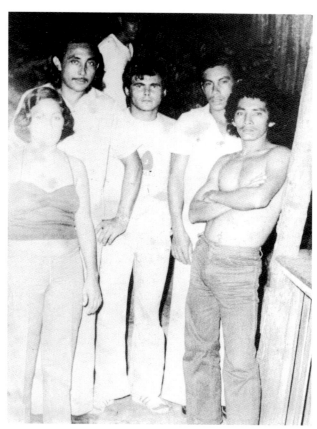

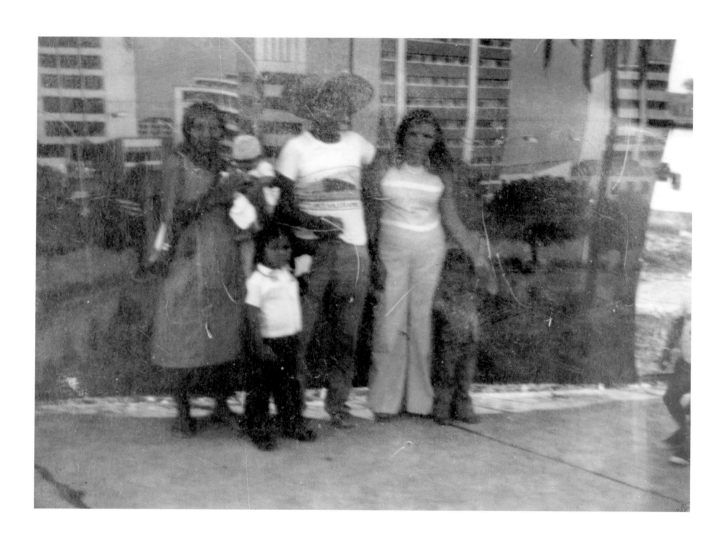

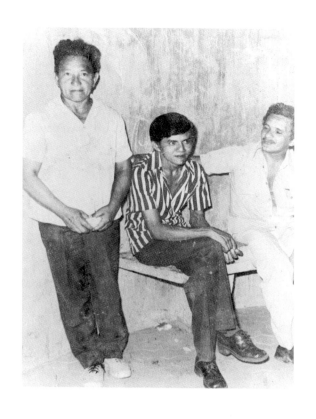

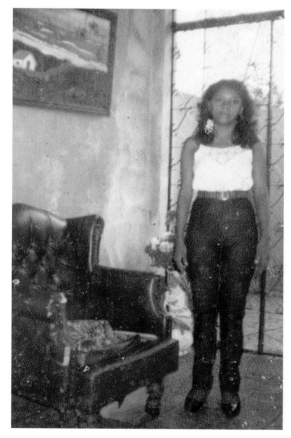

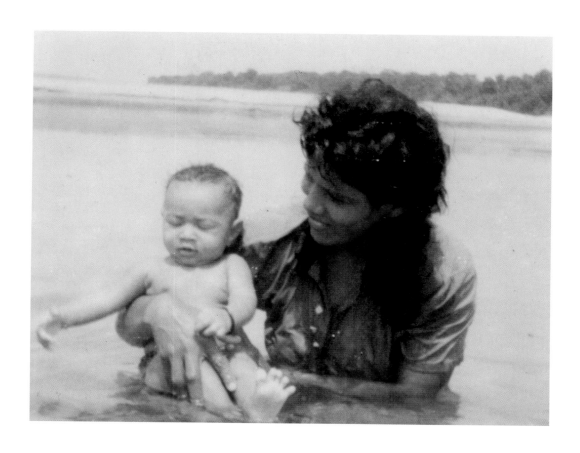

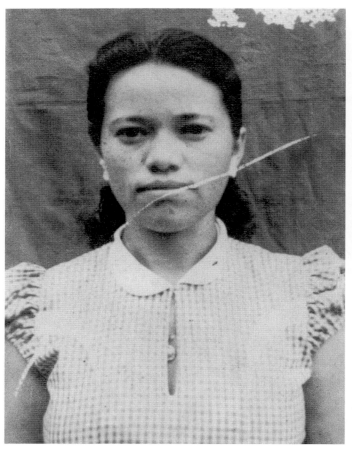
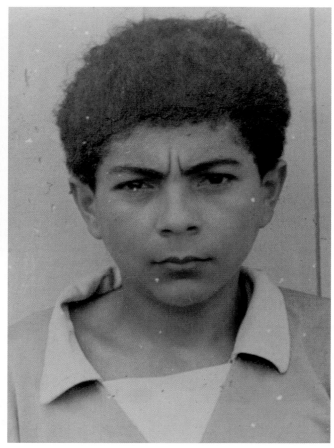

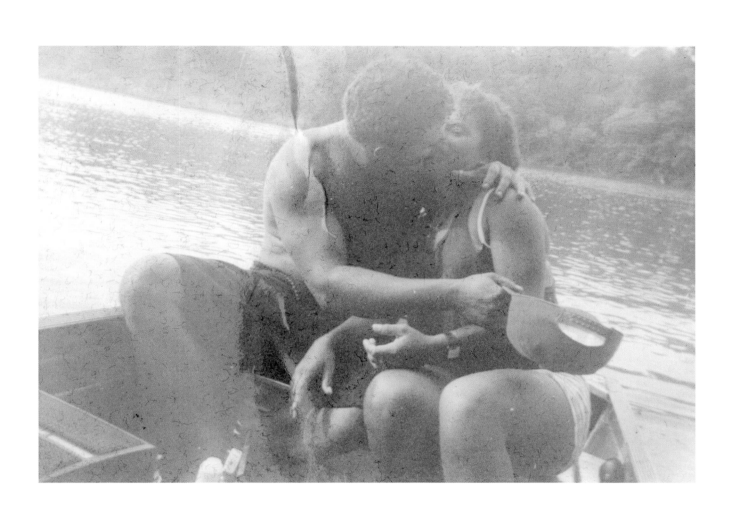

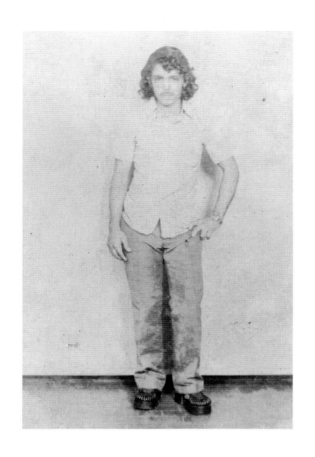

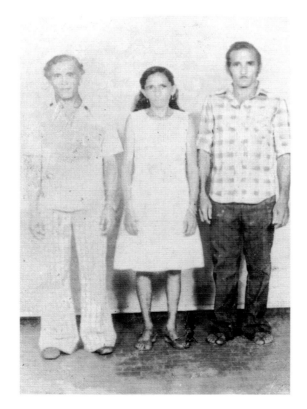

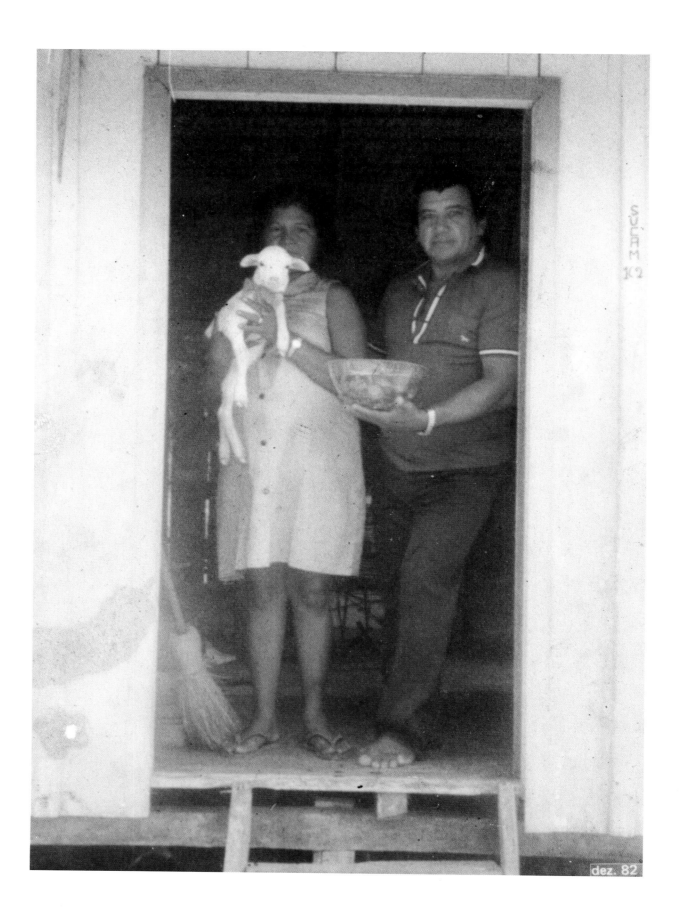

dez. 82

Apeú-Salvador: Families /
Apeú-Salvador: Familien

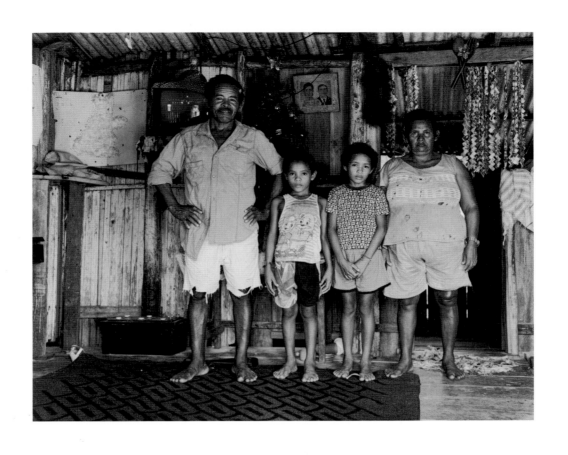

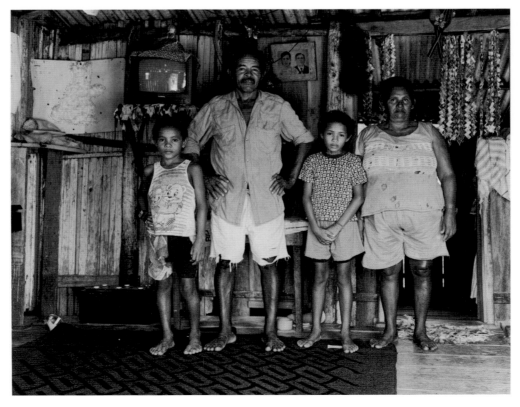

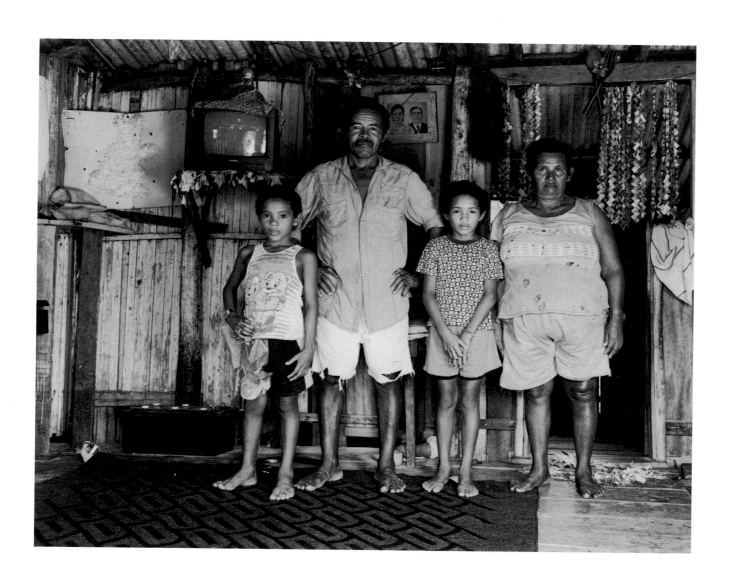

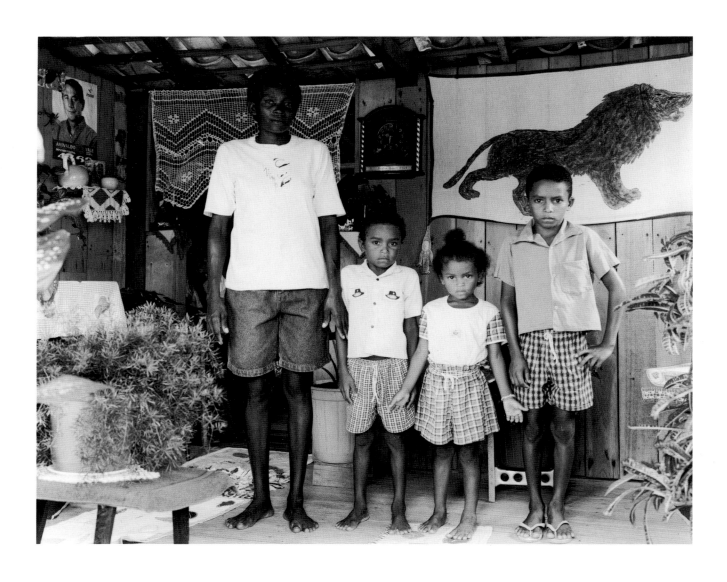

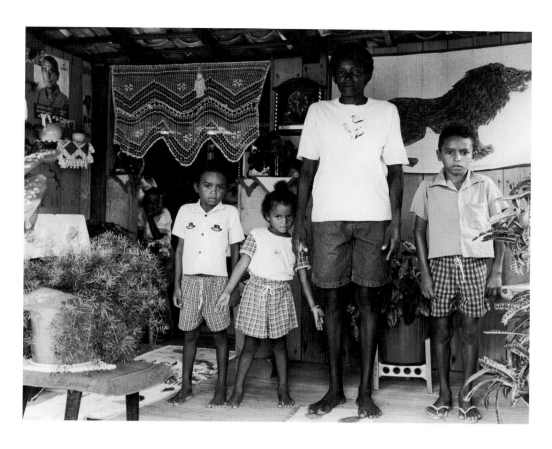

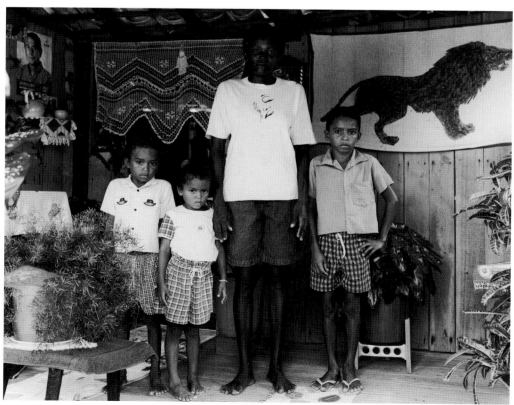

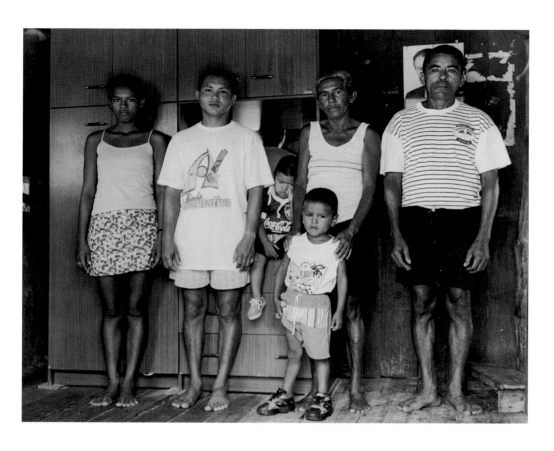

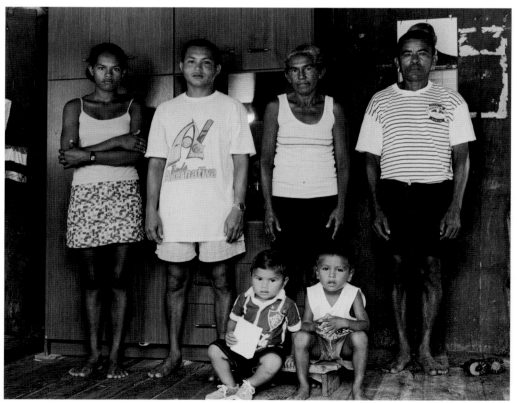

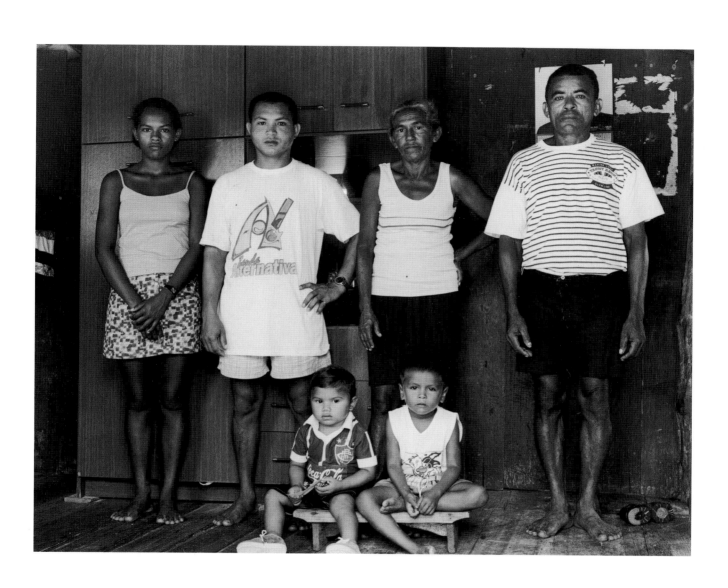

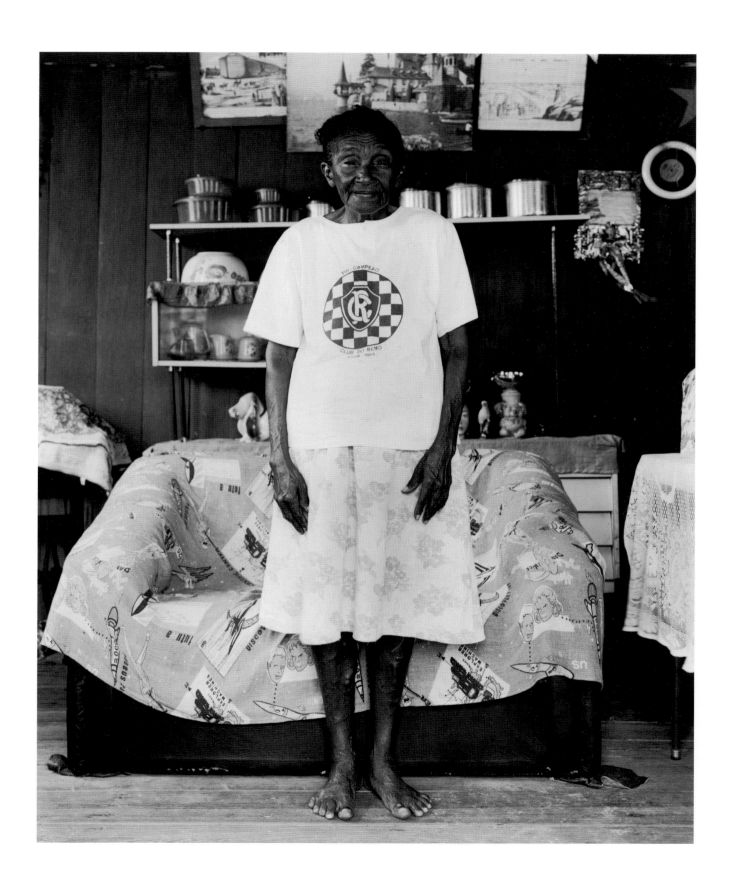

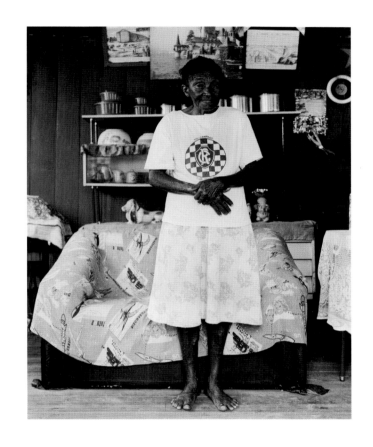

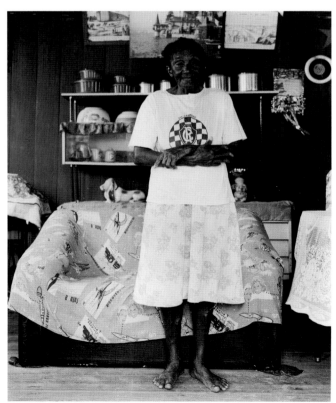

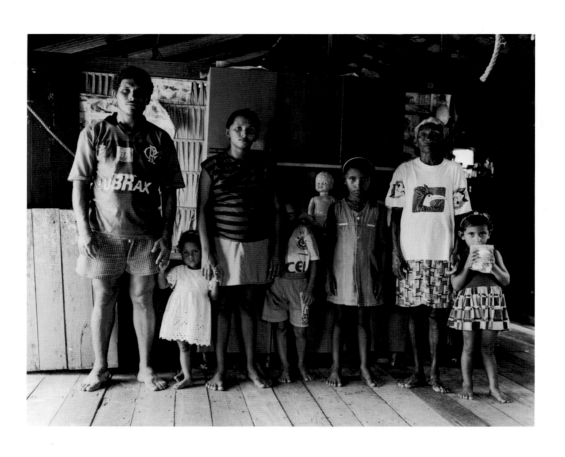

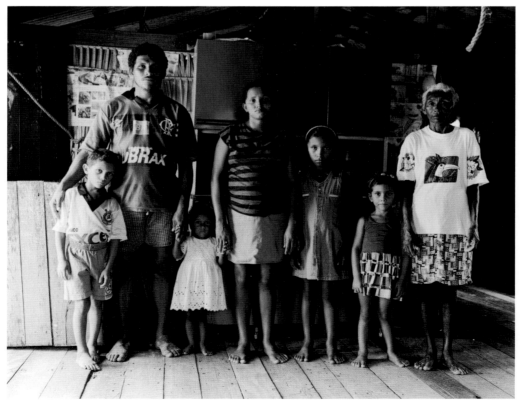

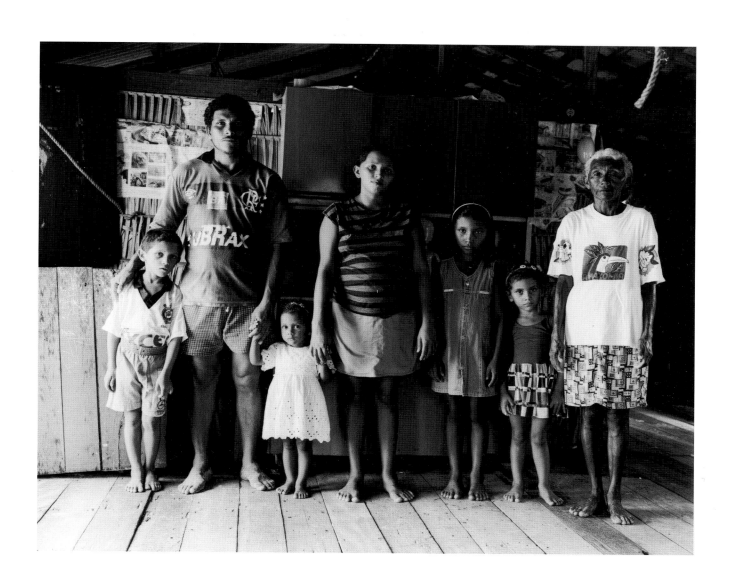

Apeú-Salvador: Maria da Conceição Pereira de Souza
with the Fruits of the Island /
Apeú-Salvador: Maria da Conceição Pereira de Souza
mit Früchten von der Insel

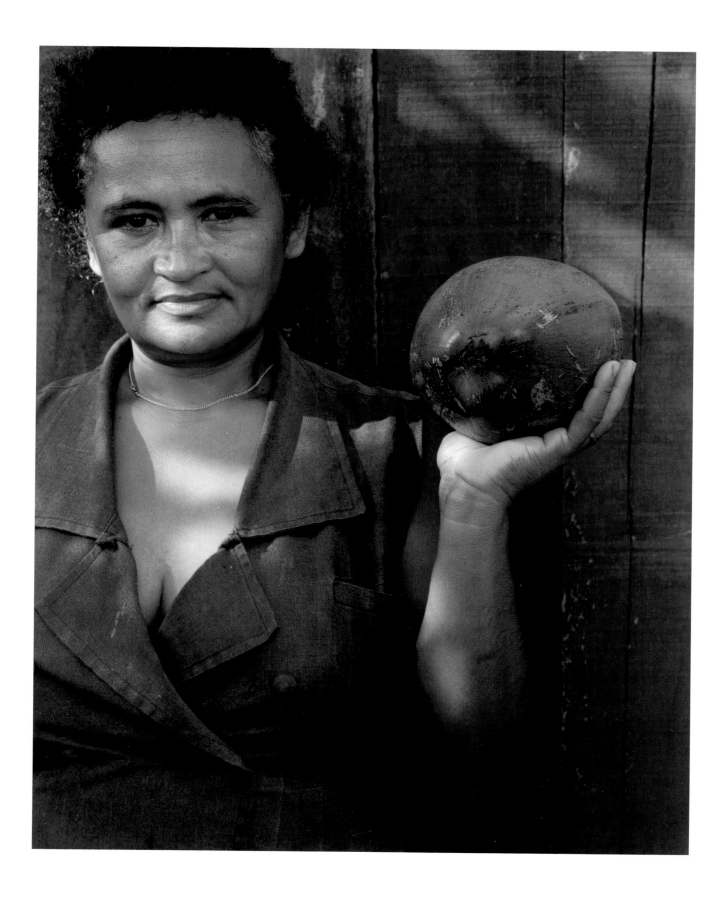

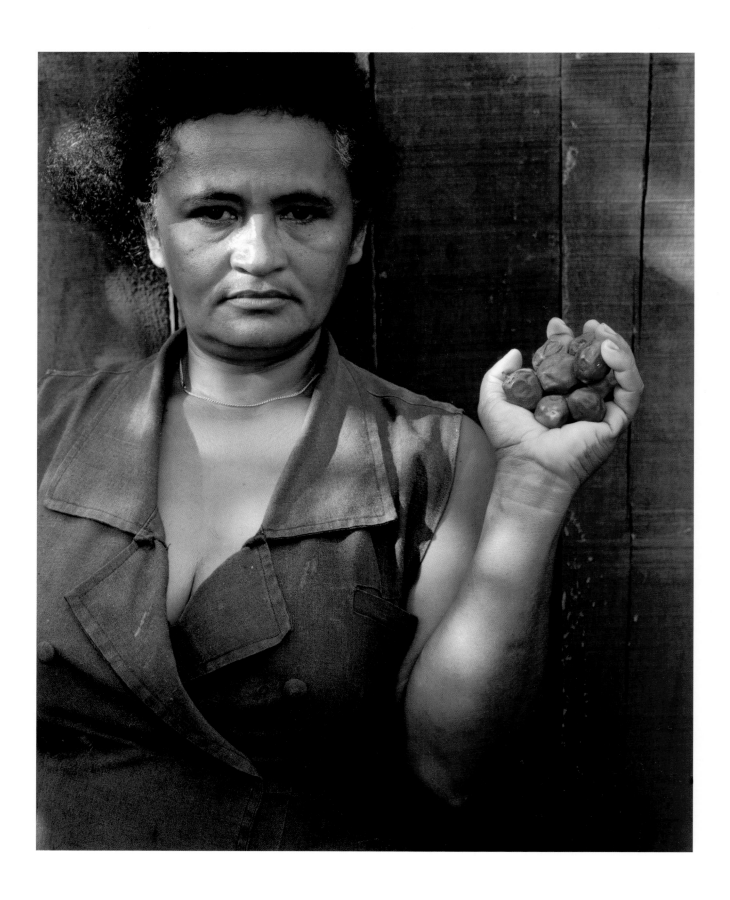

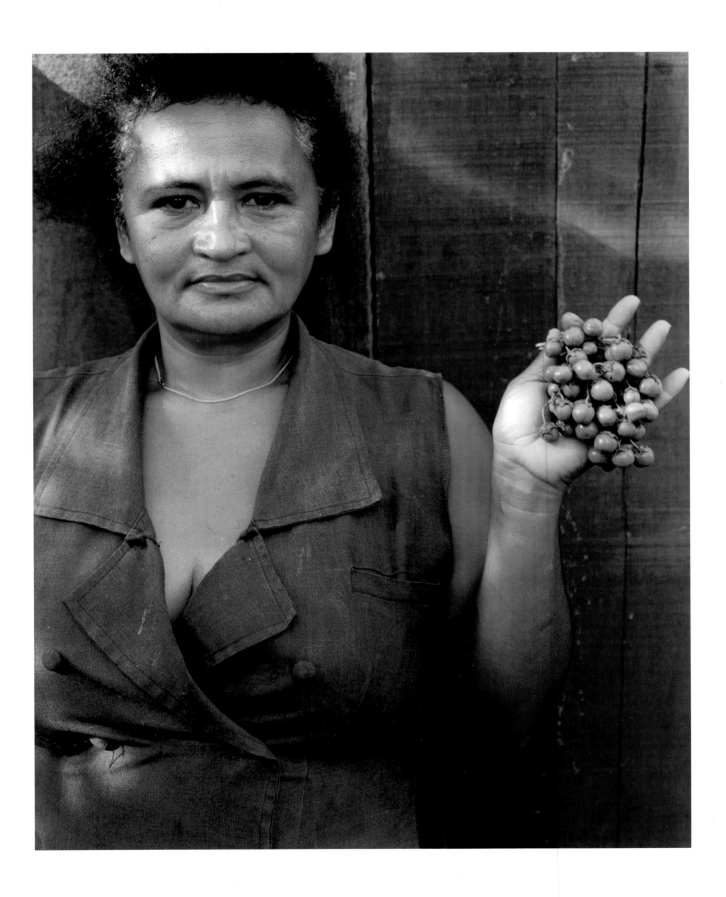

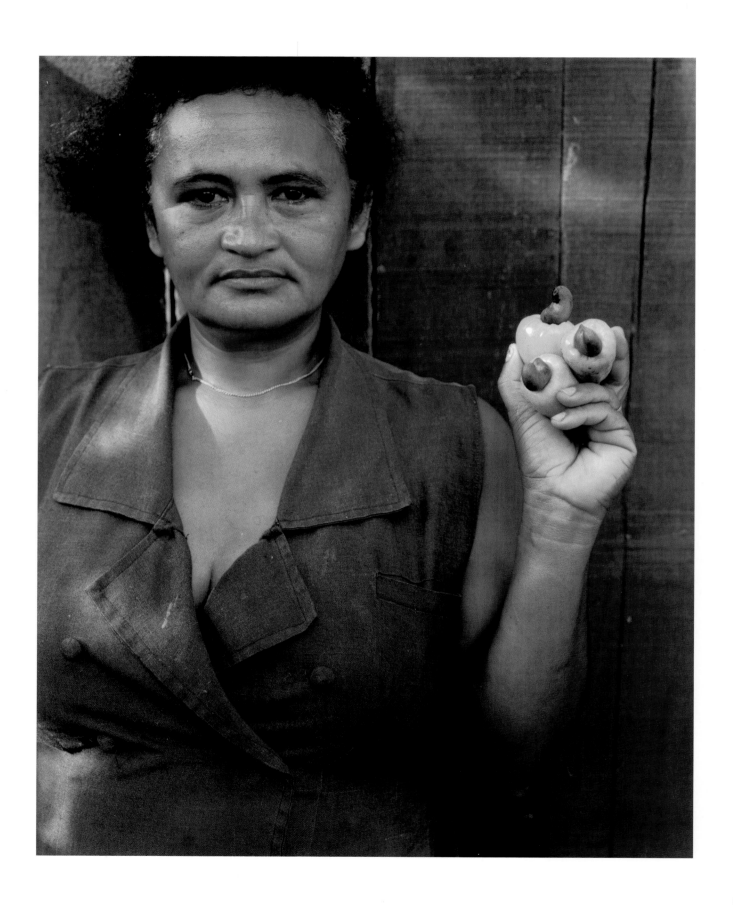

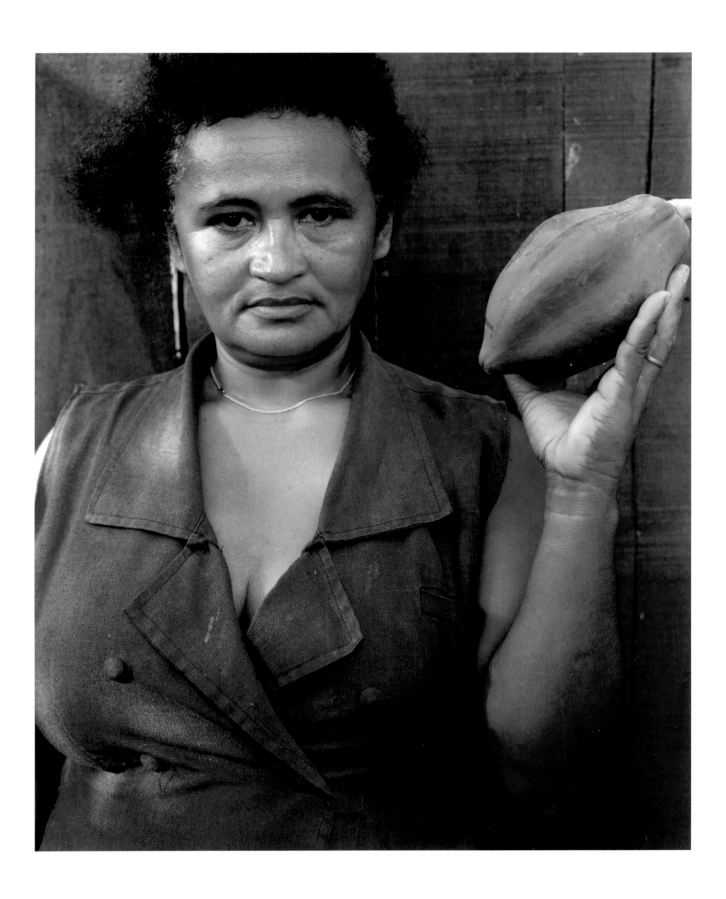

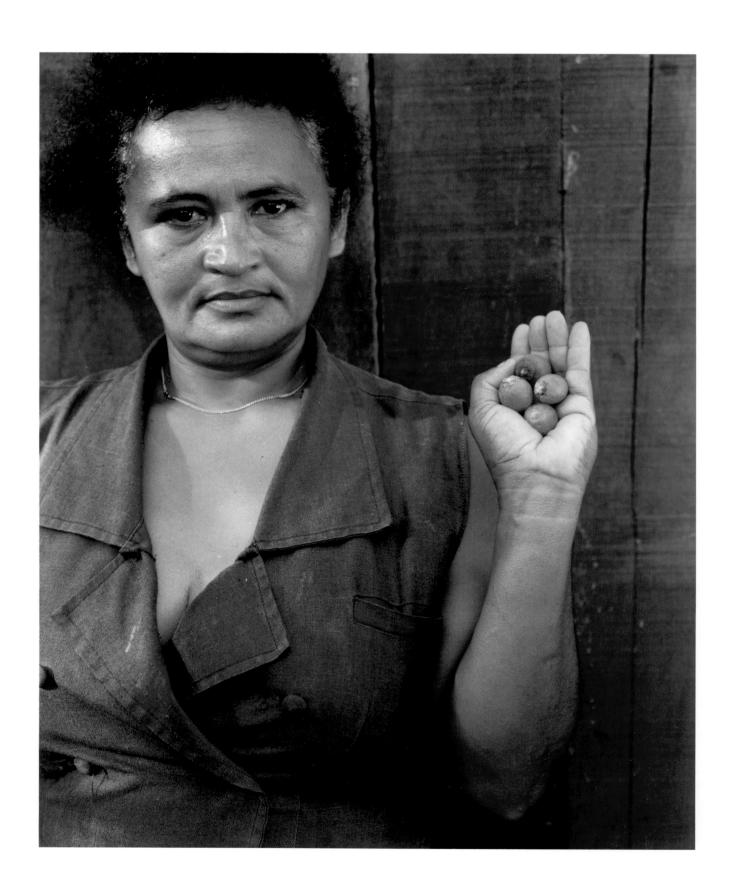

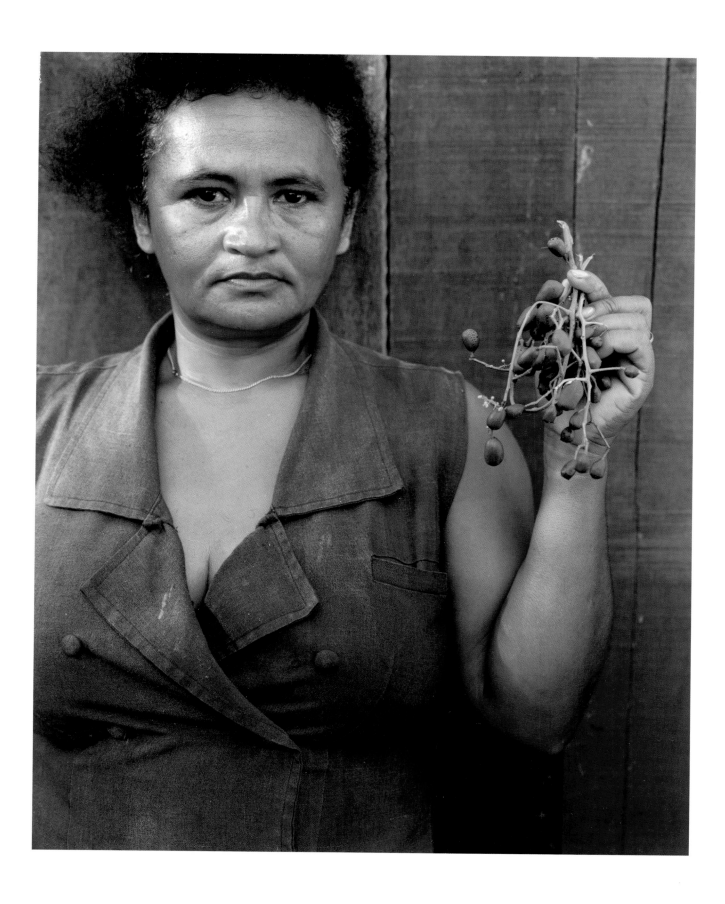

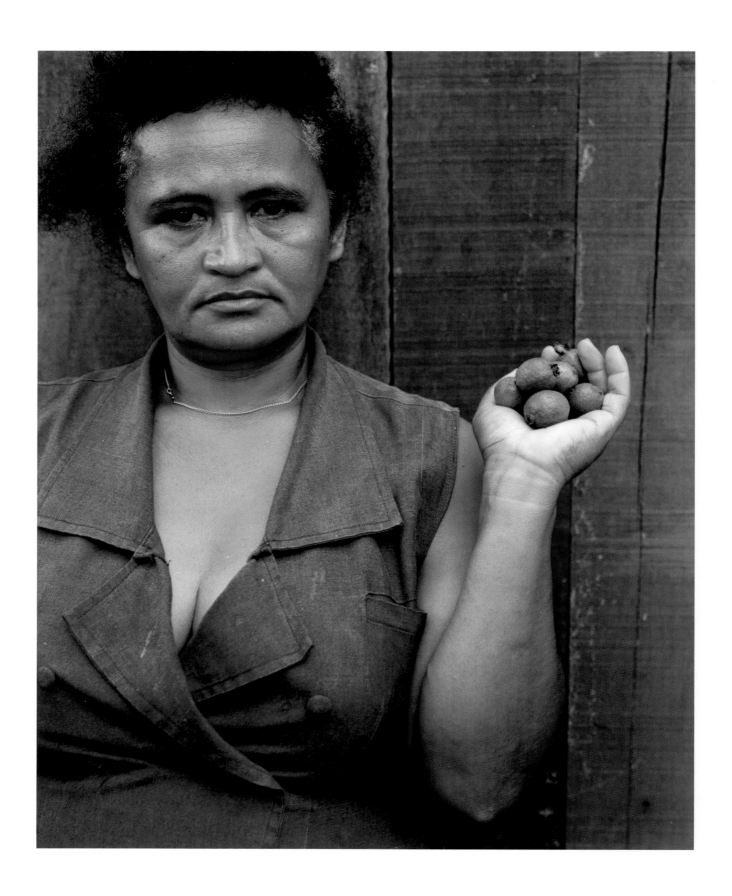

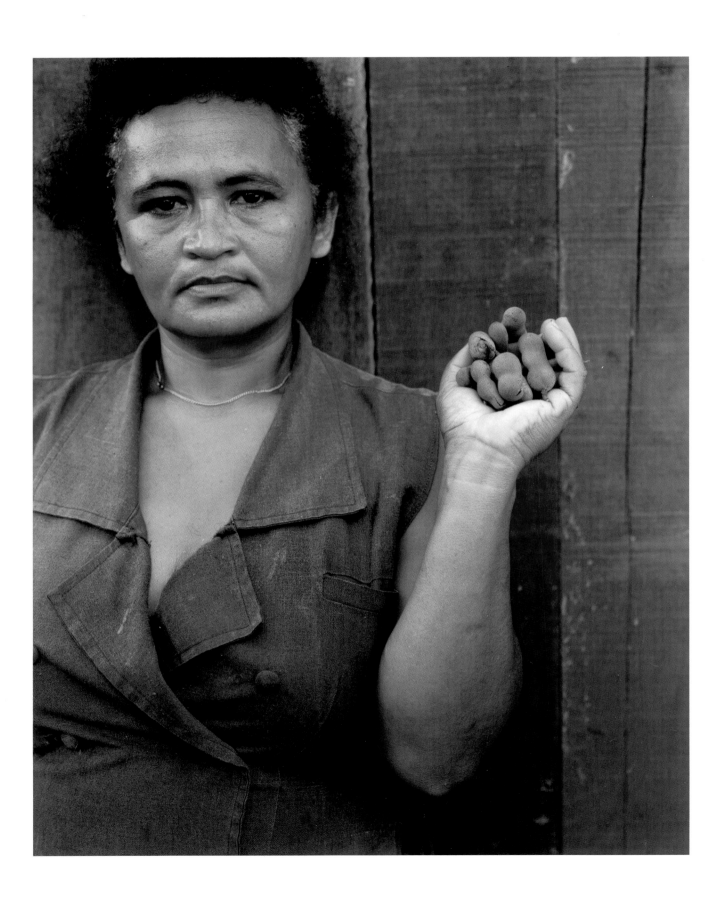

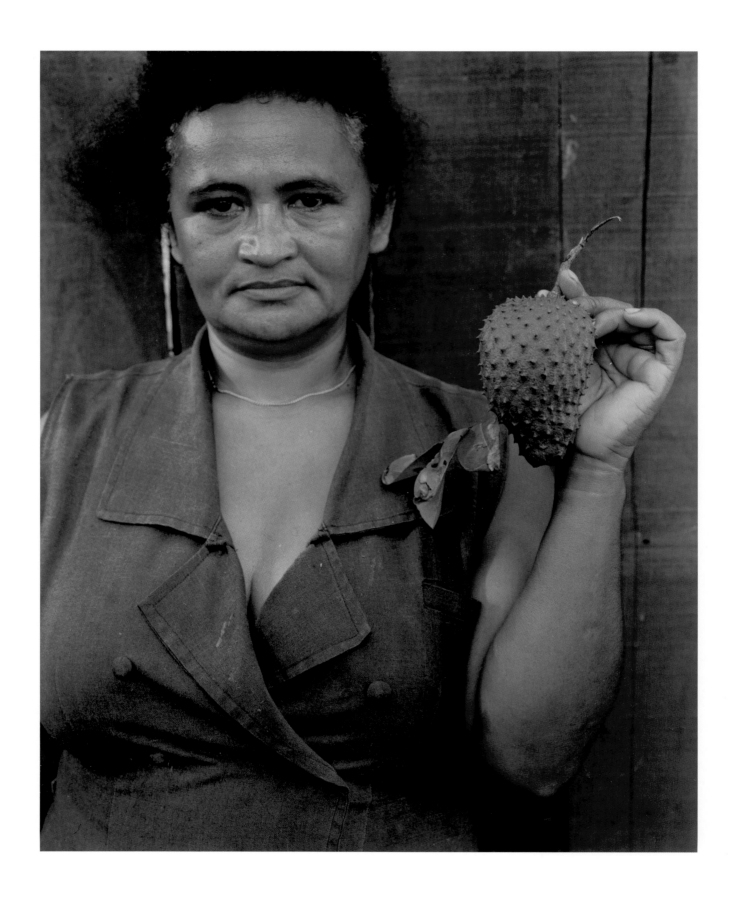

At the edge of my seat: *Teatro Amazonas* /
Auf der Kante meines Sitzes: *Teatro Amazonas*

Ivone Margulies

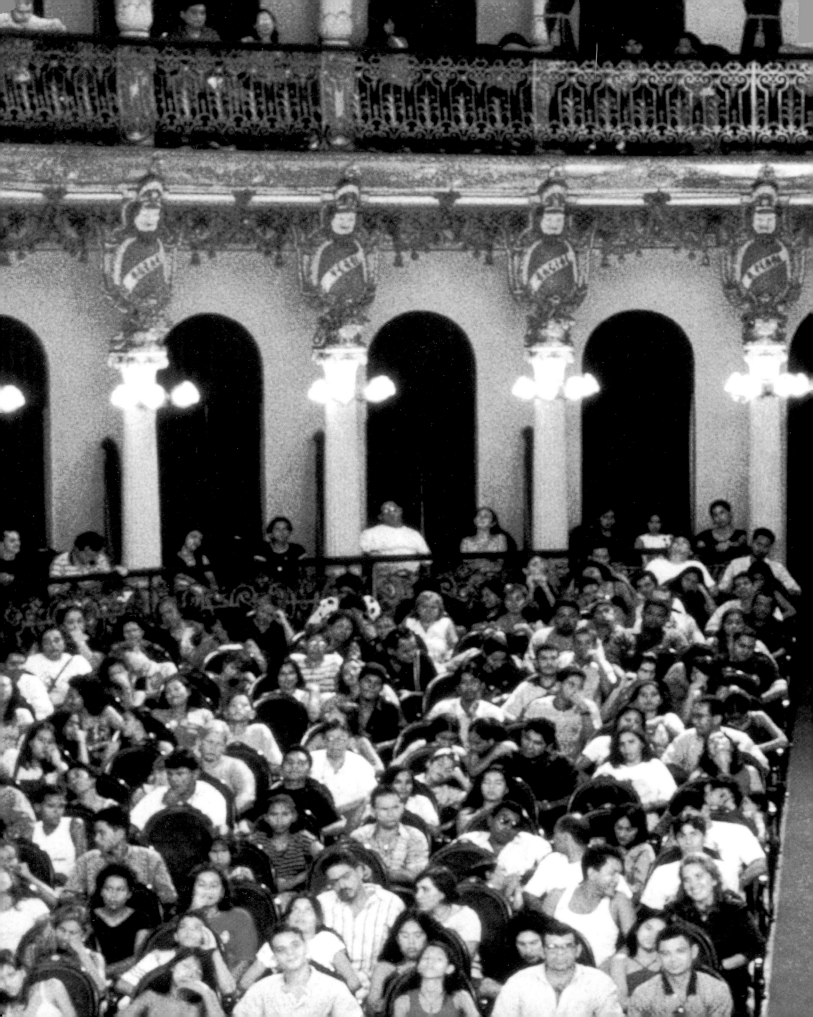

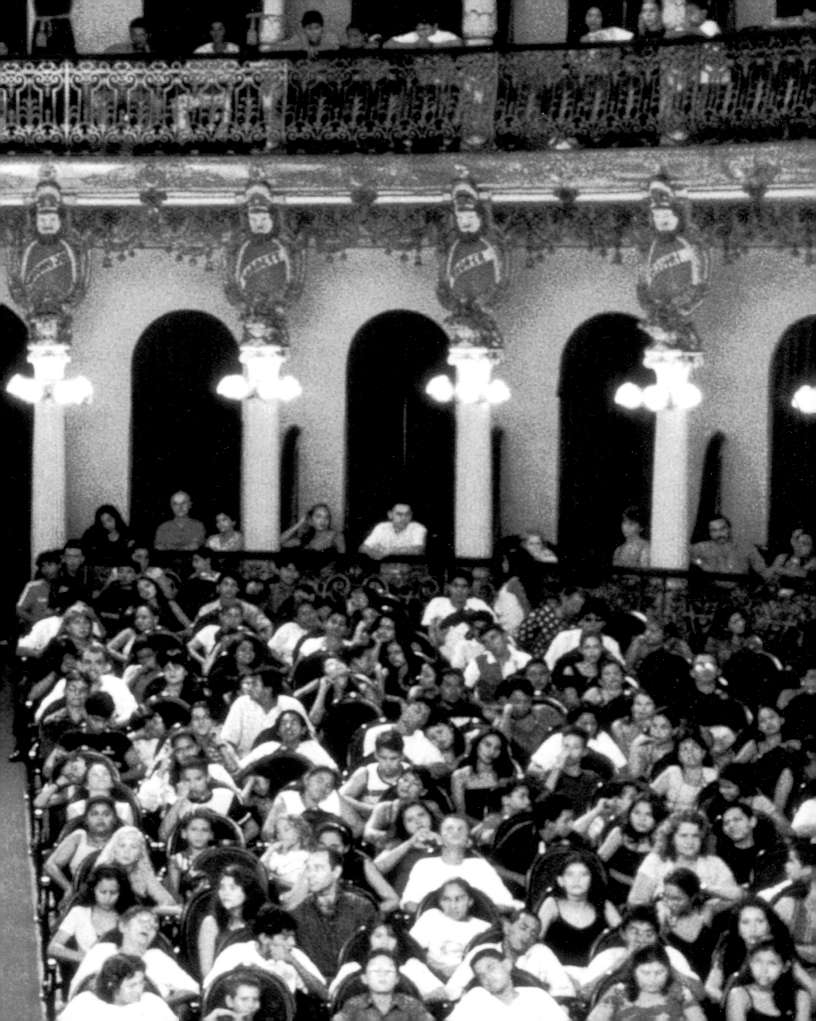

When a judging mass gazes back at us in the trial scene in Fritz Lang's *M* (1931), we understand, along with the culprit, how a reaction shot inscribes us in a drama.[1] In Sharon Lockhart's *Teatro Amazonas* (1999), an audience seated in the ornate neoclassical opera house of the same name in Manaus, Brazil, looks back at us for the twenty-nine-minute duration of the film. Yet, almost forty years after the initial impact of the technique of frontal address in the films of the French New Wave, we have never felt so unnerved by an audience gazing back. Equally unnerving is the film's strident, slightly sci-fi, minimalist choral score, which we hear along with the audience. Conceived as a sonic blanket that gradually dissolves into ambient audience sound, the score is abstract and intended to avoid imagistic associations; it does not present a marked rhythm, composed melody, or harmonic progression. And yet precisely because of its minimalist purity, this sound-track invokes the icon of another significant confrontation between different cultures, the deafening sound and blinding light of the monolith scene in Stanley Kubrick's *2001: A Space Odyssey* (1968).

Teatro Amazonas is a film that operates at the margins of the actual spectacle. In this film, the whole auditorium is evenly lit, suggesting the excitement of a show about to begin. Yet, we realize only retrospectively that this image of suspended expectancy is, in fact, the entire show. Nevertheless, the film is dramatic. And that in spite of the fact that there is nothing vaguely menacing, or even alien, in this audience of Brazilians seated in abeyance. Instead, the film's drama lies in the duration of its extended reaction shot, which is packed with subtle movement. The audience appears as a constantly shifting surface, and although its gestures and later its sounds are marked by a certain level of restraint, it embodies its own cultural distinctiveness. Heat is noticeable, as is the Brazilian women's love of long hair that needs constant twirling. But it is the film's sharp separation between the onlooker and the event that ultimately defines its theatricality,[2] and it is in the rift between the onlooker and the object of the look that Lockhart's revised ethnography emerges to vision. A succinct manifesto, *Teatro Amazonas* is a radical film on looking and cultural exchange.

Theatricality and Ethnography
The setting of the film reverberates with a long and very Brazilian history of economic and cultural elitism. Teatro Amazonas was built in Manaus, the

Teatro Amazonas, 1999 (film still/Standfoto)
35mm film
38 min./Min.
color-sound/Farb-Tonfilm
courtesy Blum & Poe, Santa Monica

Wenn uns in der Gerichtsszene von Fritz Langs *M* (1931) eine kritische Zuschauermasse entgegenstarrt, begreifen wir mit dem Beklagten, wie eine solche 'Reaktions-Einstellung' uns in das Drama einbindet.[1] In Sharon Lockharts *Teatro Amazonas* (1999) blickt uns während der gesamten Dauer des Films unentwegt ein Publikum entgegen, das in dem reich dekorierten neoklassizistischen Opernhaus gleichen Namens im brasilianischen Manaus den Zuschauerraum füllt. In den fast vierzig Jahren, seit die französischen Nouvelle-vague-Filme die Technik der 'Frontalansicht' erstmals zum System erhoben haben, hat es jedoch nie mehr einen Film gegeben, in dem ein in die Kamera starrendes Publikum so starken Eindruck gemacht hat. Nicht minder beunruhigend ist aber auch die durchdringende, andeutungsweise science-fiction-artige, minimalistische Chormusik, die wir zugleich mit den Geräuschen im Publikum hören. Diese 'Klangdecke', die sich allmählich in allerlei Geräusche aus den Zuschauerreihen auflöst, bleibt abstrakt und soll bildhafte Assoziationen vermeiden. Sie hat keinen eindeutigen Rhythmus, keine erkennbare Melodie und verzichtet auf jedwede harmonische Entwicklung. Doch gerade wegen dieser minimalistischen Reinheit beschwört diese Musik die Erinnerung an eine andere bedeutungsvolle Konfrontation zwischen verschiedenen Kulturen herauf, und zwar an die monolithische Szene in Stanley Kubricks *2001: Odyssee im Weltraum* (1968) mit ihrem ohrenbetäubenden Ton und dem blendenden Licht.

Der Film *Teatro Amazonas* zeigt die Randerscheinungen des 'eigentlichen' Theaterereignisses. Der gesamte Zuschauerraum ist gleichmäßig ausgeleuchtet und gewährt uns einen Blick auf die Anspannung, die einer Vorstellung vorausgeht. Doch erkennen wir erst im nachhinein, dass dieses Bild anhaltender Spannung bereits alles ist, was wir von der 'Aufführung' zu sehen bekommen. Trotzdem hat der Film eine ganz eigene Dramatik, und dies, obwohl das erwartungsvoll des Kommenden harrende brasilianische Publikum keineswegs bedrohlich oder befremdlich wirkt. Die Spannung ergibt sich vielmehr aus dem ausgedehnten 'reaction shot', der mit subtiler Bewegung bepackt ist. Das Publikum erscheint als unaufhörlich bewegte Oberfläche, und obwohl es sich in seinen Gebärden und später den Geräuschen, die es verursacht, durchaus zurückhält, verkörpert es eine ganz eigene Kultur. Der Betrachter spürt die Hitze geradezu am eigenen Leib und bemerkt die Vorliebe der brasilianischen Frauen für

capital of the state of Amazonas, from 1884 to 1896, and its construction was highly controversial in a city which at the time had a population of only 100,000. The theater's showy grandeur was prompted by the instant affluence that the great rubber boom in the Amazon region produced. The architects Jorge Santos and Felipe Monteiro designed the building, Henrique Mazzaloni conceived its external decor, and Crispim do Amaral was responsible for the interior, which features paintings by the Italian painter Domenico de Angelis. Initially, this theater with eight hundred seats was to be constructed almost entirely of materials imported from Europe: the building's iron framework is from Scotland, the stone and the hand-blown glass fixtures are from Italy, and the tiles are from France. In addition, the finely wrought wooden floors are made of Brazilian woods that were shipped to Europe, where they were crafted and then shipped back to Manaus. But as soon as it became difficult to import goods, local artisans started making elaborate fakeries. Cement and plaster columns, wainscoting, eyed windows, and balustrades were created to look as if they were made of marble and other noble materials. Suddenly wealthy Brazilians, identified with their former colonizers and wishing to be elsewhere than in the tropics, had their need for displacement met by trompe l'oeil. Most dramatically, as they looked up from the main floor of the auditorium, they might have believed that they were beneath the Eiffel Tower, a simulacrum of which was painted on the ceiling. Inspired by European habits, the local elite demanded and got a space in which to see and be seen.

Teatro Amazonas literalizes this relation of specularity as it trains its camera on an audience of neat but casually dressed Brazilians representing a sociological sampling of the residents of Manaus. Lockhart worked with Djalma Nogueira, a demographic consultant with the Instituto Brasileiro de Geografia e Estatistica who had produced a statistical survey of the city, to help plan the casting of the audience. Using a list of the city's neighborhoods based on the most recent census, he matched the number of seats in the camera's field of vision with the number of people that could be cast from each neighborhood. Smaller neighborhoods had proportionally fewer representatives than larger ones. This representativeness ensured that the audience included a broad participation of the city's residents, not just the local elite. But, in addition, by adopting the kind of scrutiny used in First World studies of so-called

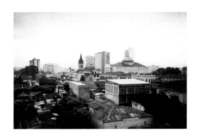

Bia Gayotto
Manaus, Brazil/Brasilien, 1999

langes Haar, das der ständigen 'Bearbeitung' bedarf. Doch seine Theatralität[2] verdankt der Film letzten Endes der scharfen Trennung zwischen Betrachter und Geschehen, und eben diesen Riss zwischen dem Zuschauer und dem Objekt seiner Betrachtung bringt Lockharts revidierte Ethnographie zum Vorschein. *Teatro Amazonas* ist daher so etwas wie ein gedrängtes Manifest, ein radikaler Film über das Sehen und die Begegnung der Kulturen.

Theatralität und Ethnographie
Der Schauplatz des Filmes ist ein Symbol für die lange und brasilientypische Geschichte eines ökonomischen und kulturellen Elitarismus. Erbaut wurde das heftig umstrittene Teatro Amazonas zwischen 1884 und 1896 in Manaus, der Hauptstadt des Staates Amazonas, die damals lediglich 100 000 Einwohner zählte, was das Projekt nur um so absurder erscheinen ließ. Seine ostentative Pracht verdankt der Bau dem schnellen Reichtum, der mit dem Kautschukboom in der Amazonas-Region Einzug hielt. Die Architekten Jorge Santos und Felipe Monteiro entwarfen das Gebäude, Henrique Mazzaloni zeichnete für den Außenschmuck und Crispim do Amaral für die Gestaltung der Innenräume verantwortlich, die mit Bildern des italienischen Malers Domenico de Angelis dekoriert sind. Zunächst wurde das Theater mit seinen achthundert Plätzen fast ausschließlich aus europäischen Importmaterialien errichtet: Die Stahlkonstruktion des Hauses stammt aus Schottland, die Steine und die handgeblasenen Beleuchtungskörper aus Italien, die Kacheln aus Frankreich. Im übrigen sind die schön gearbeiteten hölzernen Ränge aus brasilianischem Holz gefertigt, das nach Europa verschifft, dort bearbeitet und dann nach Manaus zurückgebracht wurde. Doch dann wurde es immer schwieriger, derartige Artikel zu importieren, und so machten sich die ortsansässigen Handwerker daran, kunstvolle Fälschungen zu kreieren. Die Zement- und Gipssäulen, die Täfelungen und die Fensterlaibungen und Balustraden wurden so gestaltet, dass sie den Eindruck erwecken, aus Marmor und anderen edlen Materialien geschaffen zu sein. Die reichen Brasilianer, die sich mit ihren früheren Kolonisatoren identifizierten und sich aus den Tropen fortwünschten, fanden nun ihre Sehnsucht nach einem europäischen Ambiente unversehens durch Attrappen und Augentäuscherei erfüllt. Doch noch dramatischer: Wenn sie von ihren Plätzen im Parkett nach oben blickten, konnten sie sich unter dem Eiffelturm wähnen, dessen Abbild die Decke

PIANO RECITAL BY DAVID TUDOR, APRIL FOURTEENTH, 1954, 8:40 P.M.
AT THE CARL FISCHER CONCERT HALL, 165 W. 57th STREET.

4'33" JOHN CAGE
 30"
 2'23"
 1'40"

MUSIC OF CHANGES JOHN CAGE

 •

25 PAGES EARLE BROWN
FOR PIANO II CHRISTIAN WOLFF

THIS IS THE FIRST PERFORMANCE OF 25 PAGES, THE FIRST NEW YORK PERFORMANCE OF 4'33" AND FOR PIANO II.

Piano Recital of John Cage composition by David
Tudor/Piano Recital einer John Cage-Komposition
von David Tudor
courtesy The Getty Research Institute, Research
Library, Los Angeles, 980039

ziert. Ganz wie die europäischen Vorbilder, denen sie nacheiferte, verlangte auch die einheimische Elite nach einem Ort des großen gesellschaftlichen Auftritts und sah in dem Theater die Erfüllung dieses Wunsches.

In *Teatro Amazonas* setzt Sharon Lockhart sich mit diesem Hintergrund auseinander, während sie die Kamera auf ein sorgfältig, aber lässig gekleidetes brasilianisches Publikum richtet, das die Bevölkerung der Stadt Manaus statistisch genau repräsentiert. Zu diesem Zweck hat Lockhart mit Djalma Nogueira vom Instituto Brasileiro de Geografia e Estatistica zusammengearbeitet, einem Demographen, der einen statistischen Überblick über die Bevölkerung der Stadt erarbeitete, so dass Lockhart sich bei der Auswahl des Publikums auf 'harte Zahlen' stützen konnte. Auf der Basis der neuesten demographischen Erhebungen sorgte er dafür, dass entsprechend der Zahl der vorhandenen Plätze jedes Stadtviertel im Zuschauerraum proportional vertreten war. Kleinere Viertel waren daher zahlenmäßig geringer repräsentiert als größere. Dieses Auswahlverfahren gewährleistete, dass im Zuschauerraum tatsächlich der 'typische' Bewohner der Stadt und nicht nur die Elite anwesend war. Durch Anwendung einer Methode, mit deren Hilfe Forscher aus der 'Ersten' etwas über die Kulturen der sogenannten 'Dritten Welt' in Erfahrung zu bringen hoffen, trat Lockhart zudem in einen Dialog mit den (pseudo)wissenschaftlichen Verfahren der traditionellen Ethnographie. Wir bekommen nämlich nicht etwa einen – mit Hilfe der Interview-Technik oder anderer Verfahren der authentischen Dokumentation erstellten – Bericht über alltägliches Arbeits- oder Freizeitverhalten zu sehen, sondern werden – gewissermaßen in destillierter Form – Zeuge einer Begegnung: Lockharts reflexive Ethnographie bedarf der Reaktionen der Menschen, die sie uns hier zeigt. Während wir das Publikum betrachten, das uns entgegenblickt, werden wir uns plötzlich sehr deutlich unserer eigenen Rolle als Zuschauer bewusst.

In *Teatro Amazonas* sehen und hören wir uns gewissermaßen aufgeteilt und vervielfältigt. Die untere Bildhälfte wird von einer großen Zahl von Zuschauern eingenommen, während in der oberen Hälfte die Innendekoration des majestätischen Theaters zu sehen ist. Im Rang sind noch ein paar zusätzliche Zuschauer zu erkennen: Einige von ihnen lehnen sich über die Brüstung, andere hingegen sitzen oder blicken aus teilweise abgeschlossenen Logen hervor. Während des gesamten Films legen die

Third World cultures, Lockhart engaged in a dialogue with (pseudo-)scientific methods of traditional ethnography. We are not shown a record of everyday behavior, work, or leisure habits, through talking head interviews or other verité documentary conventions. Instead, we experience in a distilled form a moment of encounter: Lockhart's reflexive ethnography can only work through a reaction shot; as we look at this audience looking at us, we become intensely aware
of our own position as onlookers.

In *Teatro Amazonas* we see, and eventually hear, ourselves split and multiplied. A large mass of audience members fills the bottom half of the frame, while the top half reveals the majestic theater's interior. Scattered throughout the upper balcony are a few more audience members; some lean over the balcony railing, while others sit, watching from partially secluded boxes. Throughout the film, people exhibit the kind of distracted attention associated with listening rather than viewing. They themselves are listening to the imperceptibly waning sounds of the Choral do Amazonas, whose members sing a score composed by Becky Allen, which is tailored to the film's twenty-nine-minute duration. The initial harmonic mass heard at the beginning of the film diminishes to silence during the course of the score's twenty-four-minute length. The choir, consisting of twelve groups of five voices each, begins with a twelve-tone cluster. Each of the twelve groups sings a single note, sustaining the tone by staggering their breathing. On their given note, they cycle through five open Brazilian vowels at different rates. The twelve tones fade one by one. As they fade, other tones with longer durations become more audible. The gradual reduction of the music allows the natural sounds of the audience – as well as the sounds audible in the space in which the onlooker is viewing the film – to emerge.

This sound transference, from a compact sonic mass into random, discrete manifestations – comments, coughs, the rustling of chairs – articulates most cogently the process of cultural exchange. There is a dialogue between on- and off-screen presences, and the transfer of sound is its conduit. The aural dissolve thus acknowledges the dual space to which the film refers. Once individuated reactions emerge from the thickly set minimalist score, they proclaim, in subtle but clear ways, their impatience and alienation from the film's conceptual maneuver and musical sensibility. Enunciating a variant on John

James Benning
11 x 14, 1976 (film stills/Standfotos)
16mm film
83 min./Min.
color-sound/Farb-Tonfilm

Leute jene zerstreute Aufmerksamkeit an den Tag, wie man sie eher mit einer Hör- als mit einer Seherfahrung in Verbindung bringt. Die Zuschauer selbst lauschen den unmerklich verklingenden Tönen des Choral do Amazonas, dessen Mitglieder ein von Becky Allen komponiertes – und genau auf den neunundzwanzig Minuten langen Film abgestimmtes – 'Klangbild' singen. Das enorme Volumen dieser Töne am Anfang des Films geht im Laufe des vierundzwanzig Minuten langen Stücks immer mehr in Schweigen über. Der aus zwölf Gruppen zu je fünf Stimmen bestehende Chor beginnt mit einem Zwölfton-Cluster. Jede der zwölf Gruppen singt eine einzelne Note und hält den Ton, solange der Atem reicht. Außerdem singen sie in unterschiedlichem Tempo auf jedem dieser Töne fünf offene brasilianische Vokale. Die zwölf Töne verklingen einer nach dem andern. Während sie verklingen, treten andere Töne von größerer Dauer in den Vordergrund. Das allmähliche Verklingen der Musik erlaubt es, dass die Geräusche, die das Publikum verursacht – aber auch jene, die im Umkreis des Filmzuschauers entstehen –, sich immer deutlicher zur Geltung bringen.

Diese Veränderung der 'Geräusch'-Kulisse – anfangs ein massives Klanggebilde, danach allerlei separate Geräusche und Stimmen – Kommentare, Husten, Stühlerücken – bringt den Prozess des kulturellen Austauschs am deutlichsten zum Ausdruck. Es kommt zu einem Dialog zwischen dem Geschehen auf der Leinwand und den Vorgängen im Off, und die sich wandelnde 'Geräusch'-Kulisse ist das Medium dieses Zwiegesprächs. Die Diffundierung der Klangkulisse dient mithin dazu, den doppelten Raum spürbar zu machen, auf den der Film verweist. Die sich aus dem machtvoll vorgetragenen minimalistischen Klanggebilde allmählich herausschälenden ersten individuellen Reaktionen bekunden ebenso subtil wie eindeutig eine gewisse Ungeduld und Entfremdung vom konzeptuellen Manöver und von der musikalischen Sensibilität des Films. Unter Rückgriff auf John Cages Gleichsetzung von Musik, Schweigen und Umgebungsgeräuschen verweist Lockhart gleichzeitig auf den Dialog zwischen Nord und Süd – das heißt auf die für die Beziehung Europa-Brasilien 500 Jahre lang dominierende koloniale Dynamik, die sich auch in dem Theatergebäude selbst so dramatisch widerspiegelt.

Lockharts formale Vorgaben bilden den rigorosen Rahmen für das Aufkommen möglicher kultur spezifischer Ereignisse. Sie jongliert mit kraftvollen, klar umrissenen Gestalten und subtilen Details – ein

Cage's equation of music, silence, and ambient sound, Lockhart thus refers at the same time to the dialogue between North and South – to the colonial dynamic that has structured the relationship between Europe and Brazil for five centuries, as the theater itself so dramatically embodies.

Lockhart's formal concerns rigorously frame the emergence of contingent, culturally specific events. She juggles with strong, defined shapes and complex, subtle details, in which each face, and mode of moving, is distinctly Brazilian – a cultural index meant to jar the film's emphatic formalism. This formalism is indebted in particular to the structuralist filmmakers of the 1960s and 1970s, such as James Benning, Morgan Fisher, Ernie Gehr, and Michael Snow. Operating through reduction and seriality, limiting its elements to a minimum and foregrounding them, these films engage the audience with permutations in a programmed series. In addition, time is used strategically: repetition creates an arc of expectation that simulates narrative, and the image can become unstable once it is seen for too long. The extended duration of shots in which barely anything happens, a form of filmic minimalism practiced by Andy Warhol in films such as *Empire* (1963), creates a perceptual oscillation between the image seen first as form, then as representation. Discussing a scene in his *11 x 14* (1976), Benning confirms this effect of duration by stating that when one watches the smokestack scene, the image clearly reads as a smokestack, but because the image is on screen for over seven minutes, at some point one begins to focus on it as swirling grain on screen. Nevertheless, after one has begun to focus on the image in these purely formal terms, an airplane passes through the scene, reintroducing narrative into the image.[3]

A similar referential instability is present in *Teatro Amazonas*. The film's extreme symmetry – with its strong lines dividing the upper balconies from the main floor and the brightly lit red carpet that splits the audience – creates a gestalt tension. As we see whole shapes, such as the rising red monolith that is the carpet, we instantly lose sight of the individual physiognomies of the audience members. Time is the key transformer. The shot's duration provokes multiple dimensions of reference to appear, which then cancel each other out.

Lockhart's sixty-three-minute film *Goshogaoka* (1997) is an important precedent in her own oeuvre in this regard. The film begins with a shot of an empty gymnasium held on screen for several

Verfahren, das jedes Gesicht und jede Bewegung als entschieden brasilianisch ausweist und den emphatischen Formalismus des Films gewissermaßen dementiert. Dieser Formalismus steht vornehmlich in der Schuld der strukturalistischen Filmemacher der sechziger und siebziger Jahre, etwa eines James Benning, eines Morgan Fisher, Ernie Gehr und Michael Snow. Diese Filme, die mit dem Verfahren der Reduktion und der Reihung arbeiten und mit einem Minimum an Elementen auskommen, fesseln das Publikum durch Permutationen in einer programmierten Serie. Überdies kommt darin der Zeit eine strategische Bedeutung zu: Die Wiederholung erzeugt einen Spannungsbogen, der eine narrative Struktur simuliert, das Bild kann zudem unstabil wirken, wenn man es zu lange betrachtet. Die lange Einstellung, in der kaum etwas passiert, eine Form des filmischen Minimalismus, deren sich auch Andy Warhol in Filmen wie *Empire* (1963) befleißigt hat, erzeugt zwischen dem zunächst als Form, dann jedoch als Repräsentation empfundenen Bild eine Art perzeptuelle Oszillation. Im Zusammenhang mit einer Szene in seinem *11 x 4* (1976) bestätigt Benning diese Wirkung der Dauer durch den Hinweis, dass das Bild in der Schornsteinszene zwar eindeutig als Schornstein erscheint, dass man jedoch irgendwann anfängt, nur noch die bewegte Körnigkeit zu sehen, weil das Bild mehr als sieben Minuten auf der Leinwand erscheint. Sobald man jedoch einmal begonnen hat, sich in dieser rein formalen Manier mit dem Bild zu beschäftigen, fliegt plötzlich ein Flugzeug über die Leinwand, so dass das Bild unversehens seine narrative Struktur zurückgewinnt.[3]

Eine ganz ähnliche Instabilität des Verweissystems ist auch in *Teatro Amazonas* zu beobachten. Die extreme Symmetrie des Films – mit den starken Linien, die die oberen Ränge vom Parkett trennen, und dem hellbeleuchteten roten Teppich, der das Publikum in zwei Gruppen teilt – bewirkt eine Art Gestalt-Spannung. Sobald wir monolithische Gebilde wie den roten Teppich betrachten, verlieren wir augenblicklich die individuellen Gesichter der Zuschauer aus den Augen. Auch hier ist wieder die Zeit das entscheidende Element. Die Länge der Einstellung bringt die verschiedensten Facetten des Geschehens ins Spiel, die sich dann wechselseitig ausheben.

Lockharts dreiundsechzigminütiger Film *Goshogaoka* (1997) ist in ihrem eigenen Werk in dieser Hinsicht ein wichtiger Vorläufer. Zu Beginn des Films ist die Kamera minutenlang auf eine leere

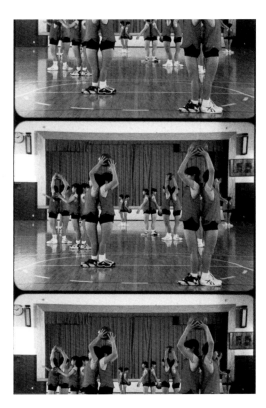

Goshogaoka, 1997 (film stills/Standfotos)
16mm film
63 min./Min.
color-sound/Farb-Tonfilm
courtesy Blum & Poe, Santa Monica

minutes. The image is extremely composed, and this excess compels us to engage in a formal game. The frame is symmetrically bifurcated, its upper part focusing on a stage, closed off by red curtains; the lower, on the polished floor of a basketball court. Suddenly a blur of motion invades the screen from left to right. The moving mass – a line of uniformed girls in their early teens running along the edge of the gymnasium and then by the edge of the raised stage – disappears and reappears. Without seeing it, we fill in the virtual circle they draw with their bodies.

This is the first of five other ten-minute single takes in which a junior high school girl's basketball team, from the Goshogaoka School, is filmed doing exercises derived from their practice routines; each of the six takes defines a different relationship to the picture frame, a formal agenda that links *Goshogaoka* to structuralist film. In addition, Lockhart's choreographic *parti-pris*, her engagement of Stephen Galloway from the Frankfurt Ballet as her movement advisor, suggests a related 1960s reference. Yvonne Rainer's and Trisha Brown's dance experiments at the Judson Church in New York are direct sources for her conversion of routine tasks into antispectacular spectacle. Purposefully ignoring the raised stage, the film repeats Rainer's and Brown's embrace of the mundane.

Moreover, in one of the greatest little homages paid to structuralist film, Lockhart seems to re-stage the scene from Yvonne Rainer's *Lives of Performers* (1974) in which Valda Setterfield dances with a ball in a mesmerizing intersection of stylized performance and the long take. The team of girls enters the frame in random formations of one or two to display their technical prowess with a ball. They each take approximately the same time to perform their stunts, which vary from bouncing the ball under one's legs, to rolling it over one's head, and even, in a streamlined display, to simply moving it slowly up. Although some girls make mistakes, their timing barely changes. It is not immediately clear when a gesture has been staged or not, for the gestures are too stylized to register as natural, and, yet, they amplify our assumptions about Japanese cultural habits. The uniformed girls suggest a chorus formation, and their Japaneseness calls forth an East/West paradigm for measuring notions of sameness and difference, of regimented group actions and individuality.[4] At the end, when the girls are directed to look at the camera, some look shyly, while others do so defiantly. Quite often, it is such a moment that tips

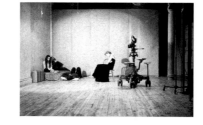

Yvonne Rainer
Lives of Performers, 1972
(production still/Foto von der Aufnahme)
photo/Foto Babette Mangolte

Sporthalle gerichtet. Das Bild wirkt ungemein artifiziell, und diese extreme Künstlichkeit zwingt uns, uns auf ein formales Spiel einzulassen. Das Bild ist symmetrisch geteilt: Seine obere Hälfte zeigt eine durch rote Vorhänge verdeckte Bühne, in der unteren sehen wir den blanken Boden eines Basketballfeldes. Plötzlich wird die Leinwand von links nach rechts von einer Bewegung erfasst. Die bewegte Masse – eine Reihe uniformierter halbwüchsiger Mädchen, die am Rand der Halle und dann am Rand der erhöhten Bühne entlanglaufen – erscheint im Bild und verschwindet wieder daraus. Ohne es mit eigenen Augen zu sehen, spüren wir den virtuellen Kreis, in dem sie sich bewegen.

Wir haben es hier mit der ersten von insgesamt sechs zehnminütigen Einstellungen zu tun, in denen das Mädchen-Basketballteam der Goshogaoka High School bei diversen Übungen gezeigt wird, die sich aus dem alltäglichen Trainingsprogramm herleiten. Jede der sechs Einstellungen zeigt einen anderen Bildauschnitt, und das formale Interesse verbindet *Goshogaoka* mit dem strukturalistischen Film. Überdies bezeugen Lockharts choreographische 'parti-pris' und der Umstand, daß sie Stephen Galloway vom Frankfurter Ballett als Bewegungsberater engagiert hat, ein Interesse an den sechziger Jahren. Yvonne Rainers und Trisha Browns Tanzexperimente in der Judson Church in New York müssen als direkte Vorbilder für Lockharts Versuch gelten, Routineaktivitäten in ein antispektakuläres Spektakel zu verwandeln. Und so ignoriert der Film ganz bewusst die erhöhte Bühne und wiederholt aufs neue Rainers und Browns Bevorzugung des Alltäglichen.

In dieser wundervollen kleinen Hommage an den strukturalistischen Film inszeniert Lockhart augenscheinlich nochmals jene Szene aus Yvonne Rainers *Lives of Performers* (1974), in der Valda Setterfield in einer faszinierenden Kreuzung aus stilisierter Performance und Langzeiteinstellung mit einem Ball tanzt. Das Mädchenteam kommt in willkürlichen Einer- oder Zweierkombinationen ins Bild und stellt sein technisches Geschick im Umgang mit einem Ball unter Beweis. Jede dieser Darbietungen dauert etwa gleich lang: Mal schieben sich die Mädchen den Ball durch die Beine, mal rollen sie ihn sich über den Kopf, oder aber sie heben ihn einfach ganz langsam in die Luft. Obwohl einige der Mädchen Fehler machen, bleibt ihr Tempo davon fast gänzlich unbeeinflusst. Auch ist nicht unmittelbar zu erkennen, welche der Gesten 'gestellt' und welche natürlich

the viewer to the delicate balance between documentary and performance so often at stake in Lockhart's work.

In Lockhart's trenchant mise-en-scènes, the image is forced to oscillate between these two poles. The documentary impulse is not entirely alien to structuralist filmmaking. In fact, several structuralist films combine extreme formal rigor with an ethnographic sensibility especially attuned to the historical and geographical particularities of a given place and time. For example, Chantal Akerman's film *Hotel Monterey* (1972) invests structuralist seriality with a comprehensive record of the spaces in and inhabitants of a welfare hotel in New York. Similarly, her dialogueless film *D'Est* (From the East, 1993) matches its formal rigor with a poignant document of Eastern Europe in the early nineties. Interior, posed shots of everyday gestures of cutting a salami or having tea condense the particulars of social place. In icy landscapes, people wait outdoors for a bus, all of them wrapped in similar fur hats and overcoats.

Similarly, instead of a detached objectivity, the duration of *Teatro Amazonas*'s single shot sets the stage for unexpected happenings. The apparent neutrality of the framing contrasts with, and therefore allows us to see, random occurrences; the dry dissection of the coordinates of the spectacle maps drama and narrative onto an entirely different plane. Within this minimalist surface, slight motions become major events. A woman dressed in yellow in the second row drifts in and out of sleep, and at one point her son touches her face to wake her up; she nods off shortly thereafter. Another boy exits and enters his row a few times. A woman throws a piece of wadded paper to a friend a couple of seats away. A tall man in a red shirt standing by the rail exits through the curtain behind him. A girl in the upper balcony leans over the railing, swinging her arm. Couples kiss. Although chance is a great part of photography and often reveals details that tie the image to reality, its emergence has no epistemological function in Lockhart's work. Instead of giving access to the reality of another culture, Lockhart re-channels contingency as an integral part of choreography.

In the sixth part of *Goshogaoka*, the girls were asked to simply follow the lines of the basketball court and stop whenever they felt like it. As they wander without a clear aim, looking down and redrawing the lines with their bodies, movement and reason are momentarily held in abeyance. Such moments of ambiguity are central to *Goshogaoka*'s,

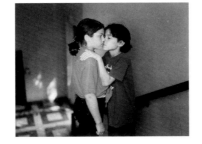

Audition Four: Kathleen and Max, 1994
5 framed chromogenic prints/
gerahmte Farb-Negativ-Drucke (detail/Detail)
124.5 x 155 cm
courtesy Blum & Poe, Santa Monica

sind, da sie ohnehin zu sehr stilisiert sind, um noch als natürlich gelten zu können. Gleichwohl nähren sie unsere Vorstellungen über die Gepflogenheiten der japanischen Kultur. Die uniformen Mädchen erinnern an eine Chorformation, und der Umstand, dass es sich um Japanerinnen handelt, kreiert gewissermaßen ein Ost/West-Paradigma, an dem sich unsere Begriffe von Identität und Verschiedenheit, von reglementierten Gruppenaktivitäten und Individualität messen lassen.[4] Als die Mädchen gegen Ende angewiesen werden, in die Kamera zu schauen, wirken einige von ihnen eher scheu, andere hingegen selbstbewusst. Gerade in solchen Augenblicken fühlt sich der Zuschauer an jene fragile Balance zwischen Dokumentation und Performance erinnert, die in Lockharts Arbeit so häufig im Brennpunkt steht.

In Lockharts präzisen Inszenierungen wird das Bild gezwungen, zwischen diesen beiden Polen zu oszillieren. Der dokumentarische Impuls ist dem strukturalistischen Filmemachen nicht völlig fremd. Tatsächlich kombinieren etliche strukturalistische Filme eine extreme formale Strenge mit einer ethnographischen Sensibilität, die sich besonders auf die historischen und die geographischen Eigenheiten eines bestimmten Ortes oder einer bestimmten Zeit einzustimmen vermag. So füllt etwa Chantal Akerman in ihrem Film *Hotel Monterey* (1972) die strukturalistische Serialität mit einem umfassenden Bericht über die Räumlichkeiten und Bewohner eines Wohlfahrtshotels in New York. Ganz ähnlich hat sie in ihrem dialoglosen Film *D´Est* (1993) formale Strenge mit einer sehr präzisen Dokumentation über das Osteuropa der frühen neunziger Jahre verbunden. Interieurs, gestellte Aufnahmen von alltäglichen Aktivitäten, etwa wenn jemand Salami schneidet oder Tee trinkt, wirken wie Kondensate der verschiedenen sozialen Orte. In eisigen Landschaften warten Menschen – allesamt mit ähnlichen Pelzmützen und Mänteln vor dem Frost geschützt – im Freien auf den Bus.

In vergleichbarer Manier schafft auch die eine lange Einstellung von *Teatro Amazonas* – fernab losgelöster Objektivität – die Bühne für unvorhergesehene Geschehnisse. Die offensichtliche Neutralität des Blickwinkels kontrastiert mit allerlei zufälligen Ereignissen und gestattet es uns, diese überhaupt zu sehen. Die trockene Zerlegung der Koordinaten des Schauspiels siedelt das eigentliche Geschehen und dessen narrative Deutung auf einer ganz anderen Ebene an. Vor diesem minimalistischen Hintergrund wirken bereits unscheinbare Bewegungen wie

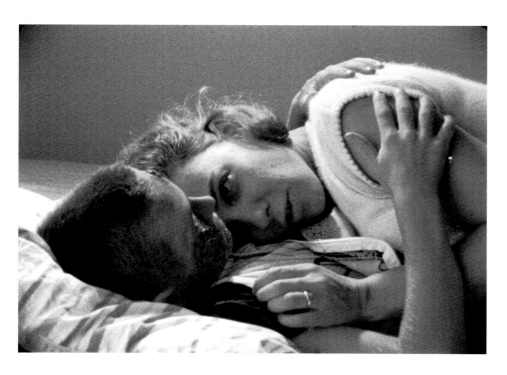

bedeutende Ereignisse. Eine gelb gekleidete Frau in der zweiten Reihe schläft zwischendurch immer wieder ein, und an einer Stelle berührt ihr Sohn ihr Gesicht, um sie zu wecken. Kurz darauf nickt sie wieder ein. Ein anderer Junge verlässt mehrmals seine Sitzreihe und kehrt dorthin zurück. Eine Frau wirft einer Freundin, die ein paar Plätze von ihr entfernt sitzt, ein Kugel Papier zu. Ein großer Mann in einem roten Hemd, der an der Brüstung steht, verschwindet durch den Vorhang hinter ihm. Ein Mädchen im oberen Rang lehnt sich über die Brüstung und lässt ihren Arm herabbaumeln. Paare küssen sich. Obwohl der Zufall in der Fotografie eine wichtige Rolle spielt und häufig Details zum Vorschein bringt, die das Bild mit der Wirklichkeit verbinden, kommt ihm in Lockharts Arbeit keine epistemologische Bedeutung zu. Statt einen Zugang zur Wirklichkeit einer anderen Kultur zu eröffnen, spielt das Unvorhergesehene bei Lockhart als integraler Bestandteil der Choreographie eine ganz neue Rolle.

Im sechsten Teil von *Goshogaoka* wurden die Mädchen gebeten, ganz einfach den Linien des Basketballfeldes zu folgen und stehenzubleiben, wann immer ihnen danach zumute war. Als sie nun ohne klares Ziel so dahingehen, nach unten schauen und die Linien mit ihrem Körper nachzeichnen, werden Bewegung und Denken für einen Augenblick in der Schwebe gehalten. Solche zweideutigen Momente machen gerade die faszinierende Wirkung solcher Filme wie *Goshogaoka* und *Teatro Amazonas* aus. Diese Augenblicke erscheinen als flüchtige, gleichsam schwebende Tablaus, die zugleich an Lockharts fotografische Arbeiten erinnern.

Probeaufnahmen: Ein von innen nach außen gekehrtes Porträt

Bei den Vorarbeiten zu *Teatro Amazonas* hat Lockhart im Laufe einer Woche rund sechshundert Probevideos gemacht, in denen Bürger der Stadt Manaus auf ihre Filmtauglichkeit hin geprüft wurden. Viele ihrer fotoserien und Filme simulieren die methodische Effizienz der Filmindustrie mit ihren Probeaufnahmen und Vorsprechterminen, wie sie auch die methodische Effizienz des Basketballspiels und der üblichen ethnographischen Studien simulieren. So ist etwa *Auditions* (1994) eine fotoserie, in der sie die Probeaufnahmen für die Kuss-Szene in Francois Truffauts Film *L'argent de poche* (1976) nachinszeniert hat. Von einem ganz ähnlichen Impetus geleitet wie Warhols Film *Kiss* (1963), ist auch diese Serie ein Experiment in Sachen starr

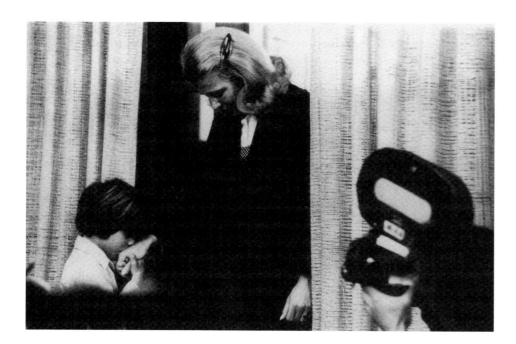

as well as to *Teatro Amazonas*'s, mesmerizing quality. These moments work as fleeting, suspended tableaux that remind one of Lockhart's work in photography.

Auditions: portraiture inside out

In preparation for *Teatro Amazonas*, Lockhart shot over the course of a week approximately six hundred casting tapes, in which residents of Manaus auditioned for the film. Many of her photograph series and films simulate the methodological efficiency of the film industry with its screen tests and auditions, just as they simulate the methodological efficiency of basketball practice and ethnographic studies. *Auditions* (1994), for example, is a series of photographs mimicking screen tests for the kissing scene in François Truffaut's film *L'argent de poche* (Small Change, 1976); as culturally defined as Warhol's film *Kiss* (1963), this series is an experiment in fixed-frame urban ethnography, a parade of diversity. But because Lockhart's work is based in the photographic, with its privileged relationship to reality, it is deceptively informative. Its order only sets into starker relief the shared vocation of productive and expendable imagery.

Lockhart's choice of what should or should not become visible in her films is not simply a matter of structuralist rigor. As she focuses on the invisible components of an image or performance – from screen tests, to realistic makeup, to the audience itself – she radically questions the set hierarchies of spectacle and visibility. Take her first film, *Khalil, Shaun, A Woman Under the Influence* (1994). In it, the graphic titles shift from identifying actual people to naming, as in film credits, actors. In the filmed portrait *Khalil*, an image of a black boy of ten is preceded by his name. After each cut, his face and body present growing marks which evoke a host of inconclusive meanings: they may have been caused by diseases or bullets, and indeed the brightly lit background suggests medical experiments or police line ups, but also institutional advertisements for Third World charities. In the next portrait, *Shaun*, a white boy in underwear stands against a neutral backdrop. Again, after each cut, he, too, displays ever larger wounds. But as he pulls at them casually, he makes clear that they originate not from a catastrophe or a disease, but from a Hollywood makeup studio.

In the third sequence of the film, Lockhart replicates one of the last scenes in John Cassavetes's film *A Woman Under the Influence* (1974), but she does not reproduce the scene literally. Instead, she dis-

Khalil, Shaun, A Woman Under the Influence, 1994
(film still/Standfoto)
16mm film
16 min./Min.
color-sound/Farb-Tonfilm
courtesy Blum & Poe, Santa Monica

John Cassavetes
A Woman Under the Influence, 1974
(production still/Foto von der Aufnahme)

fixierter Großstadt-Ethnographie beziehungsweise eine Parade urbaner Vielfalt. Freilich hat Lockharts Arbeit ihre Basis im fotographischen – mit dessen priviligierter Beziehung zur Wirklichkeit – und erscheint deshalb geradezu täuschend 'authentisch'. Ihre Ordnung rückt nur um so deutlicher die Gemeinsamkeiten zwischen produktiven und entbehrlichen Bildern in den Blickpunkt.

Lockharts Auswahl dessen, was in ihren Filmen sichtbar werden beziehungsweise unsichtbar bleiben soll, ist nicht allein eine Frage ihres strukturalistischen Rigorismus. Wenn sie ihr Augenmerk auf die unsichtbaren Komponenten eines Bildes oder einer Darbietung – handle es sich nun um eine Probeaufnahme oder ein realistisches Make-up oder um das Publikum selbst – richtet, stellt sie die vorgegebene Rangordnung von Aufführung und Sichtbarkeit radikal in Frage. Ein Beispiel dafür ist ihr erster Film *Khalil, Shaun, A Woman Under the Influence* (1994). Darin gewinnt man zunächst den Eindruck, dass in der Betitelung reale Menschen genannt werden, während man später das Gefühl hat, Schauspieler vor sich zu haben. In dem gefilmten Porträt *Khalil* wird zunächst der Name eines zehnjährigen schwarzen Jungen eingeblendet, bevor sein Bild erscheint. Nach jedem Schnitt sind auf seinem Gesicht und an seinem Körper immer mehr Male zu erkennen, die eine Vielzahl nicht ganz schlüssiger Assoziationen auslösen: Sie könnten durch Krankheiten oder Kugeln verursacht sein, und tatsächlich lässt der grell erleuchtete Hintergrund an medizinische Experimente oder an einen Polizeieinsatz denken, aber auch an die Anzeigen wohltätiger Organisationen, die sich für die Dritte Welt einsetzen. Im nächsten Porträt – *Shaun* – steht ein weißer Junge in Unterwäsche vor einem neutralen Hintergrund. Auch er stellt nach jedem Schnitt immer größere Wunden zur Schau. Doch während er lässig daran herumzupft, wird klar, dass sie nicht auf eine Katastrophe oder eine Krankheit hindeuten, sondern lediglich von einem Hollywood-Maskenbildner aufgetragen sind.

In der dritten Sequenz des Filmes repliziert Lockhart eine der letzten Szenen aus John Cassavetes *A Woman Under the Influence* (1974), ohne sie freilich buchstäblich zu reproduzieren. Sie lässt vielmehr mehrere Begegnungen in eins fallen und verstärkt damit das Hauptthema des Filmes – nämlich den Versuch, so zu tun, als ob alles in Ordnung wäre. Sie zeigt Shaun, dessen Gesicht von Blasen schrecklich entstellt ist. Versprechen künftigen Glücks erhalten somit einen eher bedrohli-

places and collapses several exchanges into one, amplifying the main theme of the film – the attempt to pretend everything is okay. She presents Shaun with his face horribly disfigured by blisters; pledges of future happiness thus become ominous. In adapting Cassavetes, Lockhart comes to the heart of the matter of his film. Cassavetes represents the character Mabel Longhetti's mad gestures, her internal scars, as a form of artistic performance, but then, also, tenderly makes them invisible. Lockhart's more conceptual film instead introduces the scars as an over-visible sign. The Hollywood horror makeup exposes, through its evident artifice, the very facticity of the image. It simultaneously produces a semantic overflow.

Lockhart is only interested in literalness if it produces a corollary representational spillover: the insistent frontality of *Teatro Amazonas* is a challenge. Can a literal, unmoving frame of a staring audience refer to something other than the notion of spectatorship? As if to verify the perfect balance between concept and figuration, Lockhart has reduced a live spectacle to its basic coordinates. She has also created a dense, layered work of portraiture.

The film's long frontal shot is, in fact, a collective portrait. The individuation that emerges from the mass of sound and seated bodies, through a comment or waving hand, is fully delivered during the film's eight-minute credits (separate from the twenty-nine-minute film itself) – a scrolling list of Brazilian names, categorized by neighborhood. Because Lockhart is at once so fascinated with conceptual purity and with individual exchange, the film achieves its maximum condensation in this sequence. As we read the credits, we realize, perhaps in retrospect, that each member of the massive audience sitting in Teatro Amazonas may, in fact, have his or her own private relation to music, theater, and performance.

In fact, in typical Lockhart fashion, the making of the film occasioned a surplus of attached images that reveal these relations. The casting tapes and the portraits of the people seen in the film, were given to each participant as a personal memento. These tapes present a more conventional ethnographic exchange than that imaged in the film itself. We learn about wages, as four municipal cleaning workers sit down to discuss their best working day, payday; about politics, as four girlfriends discuss populist tactics; about family abuse, when a woman explains how she has escaped her husband's beating. We also learn about

chen Charakter. In ihrer Cassavetes-Adaptation stößt Lockhart also auf die Kernfrage von dessen Film. Cassavetes zeigt die verrückten Gebärden, die inneren Narben seiner Figur Mabel Longhetti als eine Art künstlerische Darbietung, macht sie dann jedoch zartfühlend gleich wieder unsichtbar. In Lockharts eher konzeptuell orientiertem Film hingegen erscheinen die Narben als überdeutlich sichtbare Zeichen. Das Hollywood-Horror-Make-up bringt durch seine offenkundige Künstlichkeit gerade die Faktizität des Bildes zum Vorschein. Ja, es erzeugt zugleich eine semantische Redundanz.

An faktischer Wiedergabe ist Lockhart nur interessiert, wenn diese über sich selbst hinausweist: Die beharrliche Frontalansicht, für die sie sich in *Teatro Amazonas* entschieden hat, ist eine Herausforderung. Kann das unbewegte, getreue Abbild eines Richtung Kamera starrenden Theaterpublikums noch andere als die mit dem Begriff des Zuschauers verbundenen Assoziationen wecken? Als ob sie die vollkommene Balance zwischen Konzept und Figuration verifizieren wolle, hat Lockhart eine Live-Aufführung auf deren grundlegende Koordinaten reduziert. Zugleich hat sie aber auch eine ebenso dichte wie vielschichtige Porträtarbeit geschaffen.

Bei der langen Frontal-Einstellung des Films handelt es sich in der Tat um ein kollektives Porträt. Die individuellen Konturen der Leute, die sich aus der schieren Masse der Geräusche und menschlichen Figuren hervorschälen – sei es durch einen Kommentar oder eine winkende Hand –, werden noch durch den acht Minuten langen Abspann des Films verstärkt – eine Auflistung nach Herkunftsquartieren kategorisierter brasilianischer Namen. Da für Lockhart die konzeptuelle Reinheit und die zwischenmenschliche Begegnung gleich wichtig sind, erreicht der Film gerade in dieser Sequenz seine höchste Verdichtung. Während wir den Abspann lesen, begreifen wir – wenn auch vielleicht erst im Rückblick –, dass jeder einzelne der zahlreichen Zuschauer im Teatro Amazonas Musik, Theater und Darstellung möglicherweise mit ganz eigenen Augen sieht.

Tatsächlich haben die Vorbereitungen des Films in Lockhart-typischer Manier dazu geführt, dass wir über diverse zusätzliche Bilder verfügen, die diese spezifischen Beziehungen dokumentieren. Sämtliche Teilnehmer durften ihre jeweiligen Probe- und Porträtaufnahmen als persönliche Erinnerung mit nach Hause nehmen. Als ethnographische

the migratory patterns that have formed the region. Even the manner in which individuals came to the interviews, in large groups of neighbors, family, and friends, is revealing. The answers constitute a sociological snapshot of the Amazon region.

We are also introduced to an immense array of talent – to people who claim and prove they can dance, sing, and act. The interviewees are asked if they have ever been to Teatro Amazonas and if they have any artistic inclinations – questions by a U.S. filmmaker interpreted as an implicit invitation to chance a 'discovery.' Inspired by Lockhart's genuine interest, a number of people do, in fact, perform. These mini-performances range from abdominal exercises performed in group to a regional skit acted out by two adolescents. The monologues involve the recitation of a Native American myth and a poignant scene on begging and inequality.

In these casting tapes, Lockhart's camera does not move, and this lack of reframing creates grotesque cropping effects, particularly when individuals stand up to display their talents, their bodies blocking the viewfinder almost entirely. This perverse framing condenses Lockhart's formal ethnography. Indeed, *Teatro Amazonas's* full frontality comes at a cost: all documentary information is purged from the scene. This, suggests Lockhart in her ethnographic minimalism, is not a document of Amazonian ways of life, but a literal, live instance of dialogue.

Lockhart's literalization of the process of looking at another culture is done as a conscious bypassing of documentary conventions, a long detour premised on full sociocultural notation and then its utter voiding. We are left with an image that teases us with moments that register as significant because they are residual photographic traces of unrepeatable events. In one such climactic moment in *Teatro Amazonas*, someone opens the center red curtains and peeks into the theater. Afterwards, the curtain stays open slightly for the remainder of the film. The streak of light that invades the space becomes a trace of unstaged humanity. In a parallel stretching of the film's space, a boy sitting in the front row stands up and peeks over the red railing, which defines the bottom frame of the film, into the orchestra pit, where the chorus is located. In an era that fates photography and film to media anachronism, *Teatro Amazonas* is a loving adieu to the haphazard gesture, to the record of contingent detail – a long shot for 308 faces, 60 voices, and a grand teatro: a portrait inside out.

Dokumente kommen diese Bänder wesentlich konventioneller daher als der Film selbst. Wir erfahren dort etwas über die Löhne, wenn wir Zeuge werden, wie vier städtische Müllarbeiter sich zusammenhocken und sich darin einig sind, dass ihr bester Arbeitstag der Zahltag ist. Vier befreundete Mädchen unterhalten sich über populistische Taktiken und geben uns somit Einblick in die Politik. Über Gewalttätigkeit in der Familie werden wir durch eine Frau informiert, die erklärt, wie sie den Gewaltausbrüchen ihres Mannes entkommen ist. Auch über die Migrationsstrukturen der Gegend erhalten wir Aufschluss. Ja, selbst der Umstand, dass viele Leute zusammen mit Nachbarn, Familienangehörigen und Freunden zu den Vorgesprächen erschienen sind, lässt diverse Rückschlüsse zu. Die Antworten sind wie ein soziologischer Schnappschuss der Amazonas-Region.

Wir lernen überdies einen Riesenfundus an Talenten kennen – Leute, die behaupten und unter Beweis stellen, dass sie tanzen, singen und schauspielern können. Die 'Kandidaten' werden gefragt, ob sie zuvor schon einmal im Teatro Amazonas gewesen sind und selbst künstlerische Ambitionen hegen – Fragen einer US-Filmemacherin, die man auch als diskreten Hinweis auf die Möglichkeit einer 'Entdeckung' deuten könnte. Durch Lockharts aufrichtiges Interesse motiviert, zeigen einige der Leute tatsächlich, was sie können. Diese Mini-Auftritte reichen von den körperlichen Übungen einer Gruppe bis hin zu einer parodistischen Darbietung zweier Jugendlicher. Die Monologe beinhalten etwa die Rezitation eines amerikanischen Eingeborenenmythos oder eine Szene über Bettelei und soziale Ungerechtigkeit.

Diese Probeaufnahmen sind allesamt mit statischer Kamera gemacht, und diese Technik führt immer wieder einmal zu allerlei absurden Effekten, etwa wenn irgendwelche Leute ihr Können unter Beweis stellen wollen und dabei der Kamera mit ihrem Körper fast vollständig die 'Sicht' nehmen. Diese perverse Aufnahmetechnik bewirkt eine Verdichtung von Lockharts formaler Ethnographie. Tatsächlich hat die totale Frontalität von *Teatro Amazonas* ihren Preis: Sämtliche dokumentarischen Informationen werden gleichsam ausgelöscht. Durch ihren ethnographischen Minimalismus tut Lockhart gewissermaßen kund, dass wir es hier nicht etwa mit einer Dokumentation über das Leben in der Amazonas-Region zu tun haben, sondern unmittelbar Zeuge eines Dialogs werden.

Mit ihrem 'buchstäblichen' Blick auf eine andere Kultur umgeht Lockhart ganz bewusst die Konventionen der Dokumentation. In ihren Interviews mit den 'Kandidaten' sammelt sie zunächst detaillierte soziokulturelle Informationen, um diese hinterher einfach in der Versenkung verschwinden zu lassen. Wir bleiben mit einem Bild zurück, das uns mit Augenblicken reizt, die bedeutungsvoll scheinen, weil es sich dabei um die fotografischen Spuren unwiederholbarer Ereignisse handelt. In einem dieser herausragenden Augenblicke des Films öffnet jemand einen Spaltbreit den roten Vorhang und späht in das Theater. Danach bleibt der Vorhang während der restlichen Dauer des Films leicht geöffnet. Der Lichtstreifen, der auf diese Weise auf die Bühne fällt, wird somit zur Spur uninszenierter Menschlichkeit. Erweitert wird der Raum des Filmes aber auch in jener ähnlichen Situation, als ein Junge in der ersten Reihe aufsteht und über die rote Brüstung, die zugleich den unteren Bildrand des Films markiert, in den Orchestergraben schaut, wo sich der Chor befindet. In einer Zeit, die aus der Fotografie und dem Film einen Medienanachronismus gemacht hat, ist *Teatro Amazonas* ein liebevolles Adieu an die uninszenierte Geste, an die Aufzeichnung des zufälligen Details – eine lange Einstellung für 308 Gesichter, 60 Stimmen und ein großartiges 'teatro': ein von innen nach außen gekehrtes Porträt.

Notes

1.
The lack of a shot of M himself, played by Peter Lorre, preceding the long shot of the trial scene allows for one of the most intensely efficient reaction shots in the history of cinema. The shot contains, as in *Teatro Amazonas*, a large mass of people who sit looking at us. Its narrative implications – they wait to condemn a serial killer of children – is, of course, a dramatic version of what a staring audience may ultimately mean.

2.
When the critic Michael Fried first used the term theatricality in his essay 'Art and Objecthood' in 1967, it was to decry the way in which minimalist art took the beholder's time, becoming therefore a 'theatrical' event. With minimalism, meaning is no longer absolute, lodged in the work of art, but results from a material confrontation between two bodies. It implicates the spectator in time.

3.
See James Benning, 'James Benning,' in Scott MacDonald, ed., *A Critical Cinema 2: Interviews with Independent Filmmakers* (Berkeley: University of California Press, 1992), p. 232.

4.
Lockhart's ingenious choice of theme is also instrumental in this productive confusion. As a U.S. import, basketball was felt by the artist to be an interesting filter to look at another culture. See 'Sharon Lockhart' (Interview with Bernard Joisten), *Purple*, no.2 (Winter 1998-99), p. 329.

Anmerkungen

1.
Dass der von Peter Lorre gespielte M vor der langen Einstellung der Gerichtsszene noch nicht im Bild gewesen ist, ermöglicht eine der intensivsten Reaktions-Einstellungen der Filmgeschichte. In der Einstellung sehen wir – genau wie in *Teatro Amazonas* – eine große Zahl von Leuten, die uns anblicken. Auf der narrativen Ebene – immerhin warten die Leute darauf, einen mehrfachen Kindermörder abzuurteilen – geht es natürlich darum, zu zeigen, was ein 'starrendes' Publikum letzten Ende bedeuten kann.

2.
Als der Kritiker Michael Fried den Terminus 'Theatralität' 1967 in seinem Essay 'Art and Objecthood' erstmals in diesem Kontext verwendete, tat er dies, um sich davon zu distanzieren, wie die minimalistische Kunst die Zeit des Betrachters in Anspruch nahm und aus dieser Begegnung ein 'theatralisches' Ereignis machte. Für den Minimalismus ist die – im Werk beheimatete – Bedeutung nicht mehr absolut, sondern Ergebnis einer physischen Konfrontation zwischen zwei Körpern. Sie impliziert also den Betrachter in der Zeit.

3.
Siehe James Benning, 'James Benning', in: Scott MacDonald [Hrsg.], *A Critical Cinema 2: Interviews with Independent Filmmakers* (Berkeley: University of California Press, 1992), S. 232.

4.
Auch Lockharts geniale Themenwahl trägt zu dieser produktiven Verwirrung bei. Da es sich beim Basketball um einen US-Import handelte, glaubte die Künstlerin, dieser Sport könne ihr als Filter für einen interessanten Blick auf eine andere Kultur dienen. Siehe 'Sharon Lockhart' (Gespräch mit Bernard Joisten), *Purple*, No.2 (Winter 1998-99), S. 329.

Teatro Amazonas, 1999
production stills/Fotos von der Aufnahme
photos/Fotos Stephanie Shapiro

List of Plates / Verzeichnis der Abbildungen

Aripuanã River Region:
Interview Locations /
Aripuanã-Region:
Interview-Orte

Each work in this series consists of a framed
photograph or group of photographs. Groupings
are indicated by community name. All photographs
are framed gelatin silver prints, edition of 6.
Vertical images 81.7 x 68.3 cm;
horizontal images 69 x 81 cm./
Jede Arbeit aus dieser Serie besteht entweder aus
einem gerahmten Foto oder aber einer Gruppe von
Fotos. Die Zusammengehörigkeit mehrerer Fotos
wird durch die Angabe des Wohnortes deutlich.
Alle Fotos sind gerahmte Gelatin-Silber-Drucke.
Auflage 6. Hochformate 81,7 x 68,3 cm;
Querformate 69 x 81 cm.
Courtesy neugerriemschneider, Berlin.

p. 34
Interview Location
Survey of the Aripuanã River Region
Tucunaré Community, Paraña do Capimtuba River,
Brazil
Interview Subjects: Raimunda Ferreira,
Manoel Batista Vieira
Anthropologist: Ligia Simonian

p. 35
Interview Location
Survey of the Aripuanã River Region
São Miguel Community, Boca do Juma River, Brazil
Interview Subject: Francisco Colares
Anthropologist: Ligia Simonian

p. 36
Interview Location
Survey of the Aripuanã River Region
Miramar Community, Boca do Juma River, Brazil
Interview Subjects: Onória Reis, Manoel Ademar
Almeida Goes
Anthropologist: Ligia Simonian

p. 37
Interview Location
Survey of the Aripuanã River Region
Santa Helena Community, Boca do Juma River,
Brazil
Interview Subject: Maria Francisca de Jesus
Anthropologist: Ligia Simonian

p. 38
Interview Location
Survey of the Aripuanã River Region
Santa Luzia Community, Boca do Juma River, Brazil
Interview Subject: Maria Helena de Oliveira
Anthropologist: Ligia Simonian

p. 39
Interview Location
Survey of the Aripuanã River Region
Santa Maria do Capitari Community, Aripuanã River,
Brazil
Interview Subjects: Joana de Melo Rodrigues,
José Antônio Rodrigues
Anthropologist: Ligia Simonian

p. 40
Interview Location
Survey of the Aripuanã River Region
Santa Maria do Capitari Community, Aripuanã River,
Brazil
Interview Subject: Maria Helena Soares Ferreira
Anthropologist: Ligia Simonian

p. 41
Interview Location
Survey of the Aripuanã River Region
Natal Community, Aripuanã River, Brazil
Interview Subjects: Alexandre de Oliveira Bento,
José Luiz Cardoso, Maria de Jesus Araújo Ferreira
Anthropologist: Ligia Simonian

p. 42
Interview Location
Survey of the Aripuanã River Region
Natal Community, Aripuanã River
Interview Subject: João Damasceno
Anthropologist: Ligia Simonian

p. 44
Interview Location
Survey of the Aripuanã River Region
Piātuba Community, Aripuanã River, Brazil
Interview Subjects: Raimundo Ladislau,
Raimundo Moreira da Silva
Anthropologist: Ligia Simonian

p. 45
Interview Location
Survey of the Aripuanã River Region
Furo Grande Community, Aripuanã River
Interview Subjects: Josefa Miranda Alves,
Isaques Pereira de Souza
Anthropologist: Ligia Simonian

p. 46
Interview Location
Survey of the Aripuanã River Region
Furo Grande Community, Aripuanã River, Brazil
Interview Subjects: Clorisvaldo Pereira Miranda,
Joana D'arc Dias dos Santos
Anthropologist: Ligia Simonian

p. 47
Interview Location
Survey of the Aripuanã River Region
Furo Grande Community, Aripuanã River, Brazil
Interview Subject: Maria Lúcia Pereira Miranda
Anthropologist: Ligia Simonian

p. 48
Interview Location
Survey of the Aripuanã River Region
Boa Vista Community, Aripuanã River, Brazil
Interview Subjects: Raimunda Miranda, Antônio
Miranda Alves, Alcione Moreira de Andrade
Anthropologist: Ligia Simonian

p. 49
Interview Location
Survey of the Aripuanã River Region
Boa Vista Community, Aripuanã River, Brazil
Interview Subjects: Maria Menezes,
Maria P. Ladislau da Rocha
Anthropologist: Ligia Simonian

p. 50
Interview Location
Survey of the Aripuanã River Region
Expedition Boat, Tio D'Amico, at Boa Vista
Community, Aripuanã River, Brazil
Interview Subject: Álvaro Quadros
Anthropologist: Ligia Simonian

p. 51
Interview Location
Survey of the Aripuanã River Region
Alto Monte Community, Aripuanã River, Brazil
Interview Subjects: Cesário Lima, Doralice Miranda
de Souza
Anthropologist: Ligia Simonian

p. 52
Interview Location
Survey of the Aripuanã River Region
Regatão Boat, Comandante Bezerra,
at Pastinho Community, Aripuanã River, Brazil
Interview Subject: Antônio Noberto Bezerra
Anthropologist: Ligia Simonian

p. 53
Interview Location
Survey of the Aripuanã River Region
Pastinho Community, Aripuanã River, Brazil
Interview Subjects: Ana Lúcia das Neves Pereira,
José Guerra Açaí Cardoso
Anthropologist: Ligia Simonian

Aripuanã River Region:
Family Photographs /
Aripuanã-Region:
Familien-Fotos

Each work in this series consists of a framed photograph or group of photographs. Groupings are indicated by community name. Black-and-white photographs are framed gelatin silver prints and color photographs are framed chromogenic prints, edition of 6. Vertical images 40.4 x 32.8 cm; horizontal images 32.8 x 40.4 cm./
Jede Arbeit aus dieser Serie besteht entweder aus einem gerahmten Foto oder aber einer Gruppe von Fotos. Die Zusammengehörigkeit mehrerer Fotos wird durch die Angabe des Wohnortes deutlich. Bei den Schwarzweiss-Fotos handelt es sich um gerahmte Gelatine-Silber-Drucke, bei den Farbfotos um gerahmte Farb-Negativ-Drucke.
Auflage 6. Hochformate 40,4 x 32,8 cm; Querformate 32,8 x 40,4 cm.
Courtesy neugerriemschneider, Berlin.

p. 57
Photo from the Collection of Raimunda Ferreira and Manoel Batista Vieira, Tucunaré Community, Paranã do Capimtuba River, Brazil

p. 58
Photo from the Collection of Onória Reis, Miramar Community, Boca do Juma River, Brazil

p. 58
Photo from the Collection of Onória Reis, Miramar Community, Boca do Juma River, Brazil

p. 59
Photo from the Collection of Maria Helena de Oliveira, Santa Luzia Community, Boca do Juma River, Brazil

p. 60
Photo from the Collection of João Damasceno, Natal Community, Aripuanã River

p. 60
Photo from the Collection of Alexandre de Oliveira Bento, Natal Community, Aripuanã River, Brazil

p. 61
Photo from the Collection of Maria de Jesus Araújo Ferreira, Natal Community, Aripuanã River, Brazil

p. 61
Photo from the Collection of Maria de Jesus Araújo Ferreira, Natal Community, Aripuanã River, Brazil

p. 62
Photo from the Collection of Maria Lúcia Pereira Miranda, Furo Grande Community, Aripuanã River, Brazil

p. 62
Photo from the Collection of Maria Lúcia Pereira Miranda, Furo Grande Community, Aripuanã River, Brazil

p. 63
Photo from the Collection of Maria Lúcia Pereira Miranda, Furo Grande Community, Aripuanã River, Brazil

p. 64
Photo from the Collection of Cesário Lima and Doralice Miranda de Souza, Alto Monte Community, Aripuanã River, Brazil

p. 64
Photo from the Collection of Cesário Lima and Doralice Miranda de Souza, Alto Monte Community, Aripuanã River, Brazil

p. 65
Photo from the Collection of Antônio Noberto Bezerra, Pastinho Community, Aripuanã River, Brazil

Apeú-Salvador: Families /
Apeú-Salvador: Familien

Each work in this series consists of three framed
gelatin silver prints, edition of 6.
Vertical images 81.7 x 68.3 cm;
horizontal images 69 x 81 cm./
Alle Arbeiten dieser Serie bestehen aus drei
Gelatine-Silver-Drucken.
Auflage 6. Hochformate 81,7 x 68,3 cm;
Querformate 69 x 81 cm.
Courtesy neugerriemschneider, Berlin.

p. 68-69
The Oliveira Family
Domingos Barbosa de Oliveira, Maria Garciléia de
Oliveira, Iolanda Barbosa, Maria Nazaré de Oliveira
Apeú-Salvador, Pará, Brazil
Survey of Kinship Relations in a Fishing Community
Anthropologist: Isabel Soares de Souza

p. 70-71
The Reis Family
Maria do Livramento Soares dos Reis, Marco
Antônio Soares dos Reis, Maria Lucileide
Soares dos Reis, Marco José Soares dos Reis
Apeú-Salvador, Pará, Brazil
Survey of Kinship Relations in a Fishing Community
Anthropologist: Isabel Soares de Souza

p. 72-73
The Oliveira Family
Naíze Barbosa Ferreira, Mário Ferreira, Nadilson
Barbosa Tavares, Maria José Ferreira de Oliveira,
José Barbosa de Oliveira, Danielson Barbosa Ferreira
Apeú-Salvador, Pará, Brazil
Survey of Kinship Relations in a Fishing Community
Anthropologist: Isabel Soares de Souza

p. 74-75
The Soares Family
Lucimar Barbosa Soares
Apeú-Salvador, Pará, Brazil
Survey of Kinship Relations in a Fishing Community
Anthropologist: Isabel Soares de Souza

p. 76-77
The Monteiro Family
Manoel Nazareno Souza Monteiro, Valciria Ferreira
Monteiro, Maria da Conceição Ferreira Monteiro,
Alex Nazareno Ferreira Monteiro, Valquiria Ferreira
Monteiro, Margarida Ferreira Costa, Laudicéia
Ferreira Monteiro
Apeú-Salvador, Pará, Brazil
Survey of Kinship Relations in a Fishing Community
Anthropologist: Isabel Soares de Souza

Apeú-Salvador:
Maria da Conceição Pereira de
Souza with the Fruits of the Island /
Apeú-Salvador:
Maria da Conceição Pereira de
Souza mit Früchten von der Insel

All photographs in this series are framed
chromogenic prints, edition of 6. 44.5 x 37.9 cm. /
Alle Fotos dieser Serie sind gerahmte
Farb-Negativ-Drucke. Auflage 6. 44,5 x 37,9 cm.
Courtesy neugerriemschneider, Berlin.

p. 81
Maria da Conceição Pereira de Souza with the Fruits
of the Island of Apeú-Salvador, Pará, Brazil
(coco)

p. 82
Maria da Conceição Pereira de Souza with the Fruits
of the Island of Apeú-Salvador, Pará, Brazil
(ajirú)

p. 83
Maria da Conceição Pereira de Souza with the Fruits
of the Island of Apeú-Salvador, Pará, Brazil
(murici)

p. 84
Maria da Conceição Pereira de Souza with the Fruits
of the Island of Apeú-Salvador, Pará, Brazil
(cajú)

p. 85
Maria da Conceição Pereira de Souza with the Fruits
of the Island of Apeú-Salvador, Pará, Brazil
(mamão)

p. 86
Maria da Conceição Pereira de Souza with the Fruits
of the Island of Apeú-Salvador, Pará, Brazil
(tucumã)

p. 87
Maria da Conceição Pereira de Souza with the Fruits
of the Island of Apeú-Salvador, Pará, Brazil
(taperebá)

p. 88
Maria da Conceição Pereira de Souza with the Fruits
of the Island of Apeú-Salvador, Pará, Brazil
(goiaba)

p. 89
Maria da Conceição Pereira de Souza with the Fruits
of the Island of Apeú-Salvador, Pará, Brazil
(tamarino)

p. 90
Maria da Conceição Pereira de Souza with the Fruits
of the Island of Apeú-Salvador, Pará, Brazil
(graviola)

Biography / Biographie
Bibliography / Bibliographie

Sharon Lockhart

Norwood, Mass., 1964
lives and works in/lebt und arbeitet in Los Angeles

Education/Ausbildung
Art Center College of Design, Pasadena, M.F.A., 1993
San Francisco Art Institute, San Francisco, B.F.A., 1991

One-Person Exhibitions / Einzelausstellungen

1999

— *Sharon Lockhart*, Museum Boijmans
Van Beuningen Rotterdam/Kunsthalle
Zürich/Kunstmuseum Wolfsburg (Cat./Kat.)
— *Maria da Conceição Pereira de Souza with the
Fruits of the Island of Apeú-Salvador, Pará, Brazil*,
Pitti Immagine Discovery, Florence/Florenz
— Galerie Mot & Van den Boogard, Brussels/Brüssel
— neugerriemschneider, Berlin

1998

— *Sharon Lockhart*, The Kemper Museum of
Contemporary Art and Design, Kansas City
— Galerie Yvon Lambert, Paris
— *Goshogaoka Girls Basketball Team*,
Friedrich Petzel Gallery, New York
— *Goshogaoka Girls Basketball Team*, Blum & Poe,
Santa Monica/Wako Works of Art, Tokyo/Tokio
(Cat./Kat.)

1997

— S. L. Simpson Gallery, Toronto

1996

— Friedrich Petzel Gallery, New York
— neugerriemschneider, Berlin
— Blum & Poe, Santa Monica

1995

— *Sharon Lockhart*, Künstlerhaus Stuttgart,
Stuttgart

1994

— Friedrich Petzel Gallery, New York
— *Auditions*, neugerriemschneider, Berlin

1993

— *Shaun*, Art Center College of Design, Pasadena

Selected Group Exhibitions / Gruppenausstellungen (Auswahl)

1999

– *Life Cycles*, Galerie für zeitgenössische Kunst, Leipzig (Cat./Kat.)
– *Proliferation*, The Museum of Contemporary Art, Los Angeles
– *Looking at Ourselves: Works by Women Artists from the Logan Collection*, San Francisco Museum of Modern Art, San Francisco (Cat./Kat.)
– *Cinéma Cinéma: Contemporary Art and the Cinematic Experience*, Stedelijk Van Abbe Museum, Eindhoven (Cat./Kat.)
– *So Faraway, So Close*, Encore Bruxelles, Brussels/Brüssel (traveled to/anschließend Museum of Modern Art, Oxford) (Cat./Kat.)
– *Rodney Graham, On Kawara, Sharon Lockhart*, Friedrich Petzel Gallery, New York
– *Fast Forward Archives*, Kunstverein, Hamburg (Cat./Kat.)
– *Visions*, Les Rencontres Internationales de la Photographie, Arles (Cat./Kat.)

1998

– *Choreography for the Camera*, Walker Art Center, Minneapolis
– *L.A. Times: Art from Los Angeles in the Re Rebaudengo Sandretto Collection*, Fondazione Sandretto Re Rebaudengo, Turin (Cat./Kat.)
– *Scratches on the Surface of Things*, Museum Boijmans Van Beuningen Rotterdam (Brochure/Broschüre)

1997

– *Stills: Emerging Photography in the 1990s*, Walker Art Center, Minneapolis (Brochure/Broschüre)
– *Truce: Echoes of Art in an Age of Endless Conclusions*, SITE Santa Fe, Santa Fe (Cat./Kat.)
– *Scene of the Crime*, Armand Hammer Museum of Art, Los Angeles (Cat./Kat.)

– *Contemporary Projects: Longing and Memory*, Los Angeles County Museum of Art, Los Angeles (Brochure/Broschüre)
– *1997 Biennial Exhibition*, Whitney Museum of American Art, New York (Cat./Kat.)

1996

– *Sharon Lockhart, Stan Douglas, Hiroshi Sugimoto*, Museum Boijmans Van Beuningen Rotterdam
– *a/drift: Scenes from the Penetrable Culture*, Center for Curatorial Studies Museum, Bard College, Annandale-on-Hudson, N.Y. (Cat./Kat.)
– *Playpen & Corpus Delirium*, Kunsthalle Zürich, Zurich/Zürich (Cat./Kat.)
– *Prospect 96: Photographie in der Gegenwartskunst*, Frankfurter Kunstverein, Frankfurt (Cat./Kat.)
– *Hall of Mirrors: Art and Film Since 1945*, The Museum of Contemporary Art, Los Angeles (traveled to/anschließend Wexner Center for the Arts, The Ohio State University, Columbus, Ohio; Palazzo delle Esposizioni, Rome/Rom; Museum of Contemporary Art, Chicago) (Cat./Kat.)
– *persona*, Renaissance Society, Chicago/Kunsthalle Basel (Cat./Kat.)

1995

– *La Belle et le bête*, Musée d'Art Moderne de la Ville de Paris (Cat./Kat.)
– *Campo '95*, Venice Biennale, Venice/Venedig (traveled to/anschließend, Fondazione Sandretto Re Rebaudengo, Turin)

1994

– *Nor Here Neither There*, Los Angeles Contemporary Exhibitions, Los Angeles

Film Screenings /
Filmvorführungen

1999

– *Teatro Amazonas*
Museum Boijmans Van Beuningen Rotterdam
Teatro del Rondò di Bacco, Palazzo Pitti,
Florence/Florenz
Bonner Kinemathek, Bonn
Museum Ludwig, Cologne/Köln
Cinéma des Galeries, Mot & Van den Boogaard,
Brussels/Brüssel
– *Goshogaoka*
IASPIS/Triangelfilm, Sturebiografen, Stockholm
Film Festival STUC, Leuven
Wahlverwandtschaften, Wiener Festwochen,
Vienna/Wien
Stedelijk Van Abbe Museum, Eindhoven
– *Khalil, Shaun, A Woman Under the Influence*
Video Store II/xn 99, Espace des Arts,
Chalon-sur-Saône

1998

– *Goshogaoka*
Hirshhorn Museum and Sculpture Garden,
Smithsonian Institution, Washington, D.C.
The Museum of Modern Art and The Film
Society of Lincoln Center, New York
Künstlerhaus Stuttgart
Stockholm International Film Festival
Ahmanson Auditorium, The Museum of
Contemporary Art, Los Angeles
Museum of Contemporary Art, Tokyo/Tokio
British Council Cinema, Daniel Buchholz Gallery,
Cologne/Köln
Image Forum Festival 1998: Experimental Film
and Video, Image Forum, Tokyo/Tokio (traveled
to/anschießend Yokohama, Osaka, Fukuoka)
De Balie, Paul Andriesse, Amsterdam
Studio de Ursulines, Galerie Yvon Lambert, Paris
Cinéma des Galeries, Mot & Van de Boogaard,
Brussels/Brüssel
Rencontres Internationales de la Photographie,
Arles

Pacific Film Archive, Berkeley Art Museum,
Berkeley
The 2nd Mito Short Film & Video Festival,
Art Tower Mito, Mito, Japan
International Festival of Women's Cinema,
Boston
The New York Women's Film Festival
The Doubletake Documentary Film Festival,
Durham, N.C.
Sundance Film Festival, Park City, Utah
International Film Festival, Rotterdam
3rd Internationale Biennale Film & Architecture,
Berlin
Rassegna di Film d'Arte, Milan/Mailand
Film Festival, Milan/Mailand
Moriya Town Hall, Moriya, Japan
– *Khalil, Shaun, A Woman Under the Influence*
and *Goshogaoka*
Moderna Museet, Stockholm
Institute of Contemporary Arts, London

1997

– *Goshogaoka*
Cinema Paris, neugerriemschneider, Berlin
John Spotten Cinema, S. L. Simpson Gallery,
Toronto
Movie Theatre Accademia, Venice/Venedig
(traveled to/anschließend Les Rencontres
Internationales de la Photographie, Arles)
SITE Santa Fe, Santa Fe
– *Khalil, Shaun, A Woman Under the Influence*
and *Goshogaoka*
Celluloid Cave Screenings, The Maya Deren
Theater, Anthology Film Archives, New York
Vancouver Film Festival, Vancouver
– *Khalil, Shaun, A Woman Under the Influence*
Image Forum Festival 1997: Experimental
Film & Video, Image Forum, Tokyo/Tokio
(traveled to/anschließend Osaka, Yokohama,
Fukuoka) (Cat./Kat.)

1996

– *Khalil, Shaun, A Woman Under the Influence*
The Museum of Contemporary Art, Los Angeles

1995

– *Khalil, Shaun, A Woman Under the Influence*
Soho House, Maureen Paley/Interim Art, London

1994

– *Khalil, Shaun, A Woman Under the Influence*
Filmkunst-Studio im Schlüter, neugerriem-
schneider, Berlin
The Screening Room, Friedrich Petzel Gallery,
New York
Los Angeles Contemporary Exhibitions,
Los Angeles
Art Center College of Design, Pasadena

Selected Bibliography / Bibliographie (Auswahl)

1999

– Altstatt, Rosanne. 'Sharon Lockhart.'
Neue bildende Kunst 4 (June-July): 36-41.
– Ferguson, Russell. 'Unfinished Stories,
Unbroken Contemplation.' In *Cinéma Cinéma:
Contemporary Art and the Cinematic Experience.*
Cat./Kat. Eindhoven: Stedelijk Van Abbe
Museum, Eindhoven and/und Rotterdam:
NAi Publishers: 110-117.
– Porcari, George. 'The Photographer of Modern
Life: Some Thoughts on "Untitled," by Sharon
Lockhart.' *Inflatable Magazine*, no. 5 (Winter):
43-48.

1998

– Calame, Ingrid. 'Sharon Lockhart at Blum & Poe.'
L.A. Weekly (March 13-19): 57.
– Diamond, Dennis. '*Goshogaoka.*' *Dance on
Camera Journal* 2, no.2 (March-April): 2.
– Guenzani, Claudio. 'Interview,' *Les Rencontres
Internationales de la Photographie: Un Nouveau
Paysage Humaine.* Arles: Actes Sud.: 235-237
(Eng. trans.: 326-327).
– Hainley, Bruce. 'Shooting Hoops.' *Artforum* 36,
no. 9 (May): 19.
– Holden, Stephen. 'Tokyo Girls Play It Safe.'
New York Times (March 28): A20.
– Joisten, Bernard. 'Sharon Lockhart.' *Purple*, no.2
(Winter 1998-99): 328-335. Interview.
– Kardish, Laurence. '*Goshogaoka.*' *Sundance Film
Festival Catalogue.* (Utah: Sundance Film
Institute): 200.
– Kitanokoji, Takashi. 'The Girls' Line of Vision Calls
Our Attention to the Space Outside of the
Frame.' *Studio Voice* (April): 116-121.
– Miyamura, Noriko. 'Art and Environment's
New Relationship.' *Bijutsu Techo* (April): 200.
– Reynaud, Berenice. '*Goshogaoka.*' In *Sharon
Lockhart.* Cat./Kat. Santa Monica: Blum & Poe
and/und Tokyo: Wako Works of Art: 25-30.

– Rossing Jensen, Jorn. 'Goshogaoka.' *Dagkrant*, (February 6): 11.
– Schwendener, Martha. 'Sharon Lockhart.' *Time Out New York* (April 2-9): 45.
– Silva, Arturo. 'Freeze Frames and Blank Expressions.' *The Japan Times* (February 15): 13.
– Smith, Roberta. 'Sharon Lockhart.' *New York Times* (March 20): B35.
– Wahjude, Claudia. 'Sightings: New Photographic Art.' *Kunstforum International* 141 (July-September): 431-433.

1997

– Bonami, Francesco. *Truce: Echoes of Art in an Age of Endless Conclusions.* Santa Fe: SITE Santa Fe: 26, 74-75, 102.
– DeBord, Matthew. 'The Recurrent American Rhetoric of Contradiction: Sharon Lockhart's Photographs.' *Siksi: The Nordic Art Review* 12, no.3 (Autumn): 76-79.
– Intra, Giovanni. 'Sharon Lockhart, Laura Owens, Frances Stark.' *Flash Art*, no.197 (November-December): 76.
– Kliewer, Brent. 'Exploring Multicultural Issues.' *Pasatiempo* (August 8-14).
– Miles, Christopher. 'Sharon Lockhart's Short and Long Images.' *SOMA* (July): 20-21.
– Pokorny, Sydney. 'Sharon Lockhart.' *Artforum* 35, no.8 (April): 92.
– Rugoff, Ralph. *Scene of the Crime.* Cat./Kat. Los Angeles: Armand Hammer Museum and/und Cambridge, Mass.: MIT Press: 92, 122.
– Salvioni, Daniella. 'The Whitney Biennial: A Post 80s Event.' *Flash Art*, no.195 (Summer): 114-117.
– Stjernstedt, Mats. 'On a Fairly Traditional Exhibition Rhetoric: Whitney Biennial.' *Siksi: The Nordic Art Review* 12, no.2 (Summer): 83.

1996

– Bloom, Amy. 'A Face in the Crowd.' *Vogue* (December): 292-297.
– Bonami, Francesco, ed. *Echoes: Contemporary Art in the Age of Endless Conclusions.* New York: Monacelli Press: 154-155.

– Brougher, Kerry. *Hall of Mirrors: Art and Film Since 1945.* Cat./Kat. Los Angeles: The Museum of Contemporary Art and/und New York: Monacelli Press: 120-122.
– Greene, David A. 'Home Movies.' *Village Voice* (November 26-December 3): 93.
– Greenstein, M. A. 'Sharon Lockhart.' *Art Issues*, no. 43 (Summer): 37.
– Martin, Timothy. 'L.A.: Particles and Waves.' *Studio* 246. Cat./Kat. Künstlerhaus Bethanien.
– Myers, Terry. *New Art Examiner* (Summer): 45-46.
– Rugoff, Ralph. 'Lost at the Mall: Searching for the Intersection of Art and Film.' *L.A. Weekly* (March 29-April 4): 41.
– Saltz, Jerry. 'Sharon Lockhart.' *Time Out New York* (November 28-December 5): 46.
– Scanlan, Joe. 'Let's Play Prisoners.' *Frieze*, no.30 (September-October): 60-67.
– Stjernstedt, Mats. 'Omtagninagar: Sharon Lockharts arbeiten med film/Retakes: Sharon Lockhart's Work in Film.' *Paletten*, no.224 (January): 31-36.

1995

– Aukeman, Anastasia. 'Sharon Lockhart.' *Art in America* 83, no. 4 (April 1995): p. 112.
– McDonald, Daniel. 'Sharon Lockhart.' *Frieze*, no. 20 (January-February 1995): pp. 63-64.

1994

– Cooper, Dennis. 'Love Poems Produced by Staring Too Hard at Thomas.' In *Uncontrollable Bodies: Testimonies of Identity and Culture.* Seattle: Bay Press.
– Diedrichsen, Diedrich. 'Oostende.' *Texte zur Kunst*, no. 15 (June 1994): pp. 214-217.
– Meier, Eva. 'Sharon Lockhart.' *PAKT* (September-October 1994), pp. 12-13.
– Relyea, Lane. 'Openings: Sharon Lockhart.' *Artforum* 33, no. 3 (November 1994): pp. 80-81.

This publication accompanies the exhibition/
Diese Publikation begleitet die Ausstellung
Sharon Lockhart

20.11.1999 – 06.02.2000
Museum Boijmans Van Beuningen Rotterdam
Museumpark 18-20, NL-3015 CX Rotterdam
Tel. 31 10 4419 400
Fax 31 10 4360 500

25.03.2000 – 21.05.2000
Kunsthalle Zürich
Limmatstrasse 270, CH-8005 Zürich
Tel. 41 1 272 15 15
Fax 41 1 272 18 88

09.06.2000 – 10.09.2000
Kunstmuseum Wolfsburg
Porschestrasse 53, D-38440 Wolfsburg
Tel. 49 5361 266 90
Fax 49 5361 266 911

Exhibition organized by/Ausstellungsorganisation
Karel Schampers, Sharon Lockhart
Zürich: Bernhard Bürgi
Wolfsburg: Veit Görner
Assistance/Assistenz
Rotterdam: Marion Busch
Zürich: Bettina Marbach
Wolfsburg: Manfred Müller
Technique/Technik
Rotterdam: Wout Braber
Zürich: Daniel Hunziker, Martin Schnidrig
Wolfsburg: Roland Konefka-Zimpel

Lenders to the exhibition/Leihgeber
AMP, New York
Blum & Poe, Santa Monica
Collection Goetz, Munich/München
Uta Grosenick, Cologne/Köln
Sharon Lockhart, Los Angeles
Mora Foundation
neugerriemschneider, Berlin
Friedrich Petzel, New York
Private collection/Privat Sammlung, Cologne/Köln
and lenders who wish to remain anonymous/
und Leihgeber, die anonym bleiben möchten.

Catalogue/Katalog
Karel Schampers, Sharon Lockhart
Texts edited by/Textredaktion
John Alan Farmer
Translation Übersetzung
Nansen (T. Martin)
Christian Quatmann (Vorwort, I. Margulies)
Catalogue design/Kataloggestaltung
Gracia Lebbink
Typesetting/Schriftsatz
Holger Schoorl
Photographic printing/Foto-Abdrucke
Reece Vogel, South Pasadena
Printing and lithography/Druck und Lithografie
Drukkerij Die Keure, Brugge
Production/Produktionsbegleitung
Barbera van Kooij – NAi Publishers Rotterdam
Publisher/Herausgeber
Museum Boijmans Van Beuningen Rotterdam
Simon Franke – NAi Publishers Rotterdam

Available in North, South and Central America
through D.A.P./Distributed Art Publishers Inc, 155
Sixth Avenue 2nd Floor, New York, NY 10013-1507,
Tel. 212 627.1999 Fax 212 627.9484

Available in the United Kingdom and Ireland
through Art Data, 12 Bell Industrial Estate, 50
Cunnington Street, London W4 5HB, Tel. 181-747
1061 Fax 181-742 2319

ISBN
90-5662-139-4

Corporate Members/Fördernde Unternehmen
Museums Boijmans Van Beuningen Rotterdam:

ABN AMRO Bank N.V.; CALDIC; Internatio-
Müller NV; DURA VERMEER GROEP N.V.;
Aon Hudig; Koninklijke Nedlloyd N.V.; Unilever;
Loyens & Volkmaars; Koninklijke Econosto N.V.;
Koninklijke Pakhoed N.V.; MeesPierson N.V.;
Gimbrère en Dohmen Software B.V.; HBG
Utiliteitsbouw bv regio West; Generale Bank
Nederland N.V.; Ernst & Young; Nauta Dutilh;
Siemens Nederland N.V.; PTT Telecom District
Rotterdam; Bakker Beheer Barendrecht BV;
Mobil Oil B.V.; Nationale Nederlanden; Van der
Vorm Vastgoed B.V.; Heineken Nederland B.V.;
Glaxo Wellcome B.V.; HAL Investments B.V.;
KPMG Accountants Belastingadviseurs
Consultants; SGS Nederland B.V.;
Stichting Organisatie van Effectenhandelaren te
Rotterdam; Nidera Handelscompagnie b.v.;
Automobielbedrijf J. van Dijk & Dochters b.v.;
KOEN VISSER GROEP; Stad Rotterdam
Verzekeringen; Gebrs. Coster Beheer B.V.;
Croon Elektrotechniek B.V.; Europees Massagoed-
Overslagbedrijf (EMO) bv; Blauwhoed bv;
Gemeente Rotterdam, Afdeling Externe
Betrekkingen; De Brauw Blackstone Westbroek

I wish to thank the following persons for their
participation in this project/Ich danke den
folgenden Personen für ihre Mitarbeit and
diesem Projekt: Becky Allen, Lisa Anne Auerbach,
Kirsten Biller, Timothy Blum, Hans Jurgen Bonack,
Pieter Jan Brugge, Bernhard Burgi, Marion Busch,
Sarah Cohen, Chris Dercon, John Alan Farmer,
The Anthropology Department at Universidade
Federal do Pará, Russell Ferguson, Helen Green
Dove, Jane Hart, Alice Kasakoff, Rebekka
Ladewig, Gracia Lebbink, Ivone Margulies,
Timothy Martin, Caito Martins, David Maupin,
John McColpin, Roberto Motta, Tim Neuger,
Fabricia da Silva Oliveira, Bruce Osborn,
Ron Osterberg, Dr. Wagner Pereira, Friedrich
Petzel, Jeffrey Poe, Stephen Prina, Burkhard
Riemschnieder, Alma Ruiz, Karel Schampers,
Joshua Siegal, Ligia Simonian, Isabel Soares de
Souza, Haruko Tanaka, Gercilene Teixeira,
Helen van der Meij, Barbera van Kooij,
Gijs van Tuyl, Reece Vogel, Jochen Volz,
and Lynn Zelevansky.

I would especially like to thank Karel Schampers
for his extraordinary commitment, which made
this exhibition and book possible. /
Mein besonderer Dank gilt Karel Schampers
für seine außergewöhnliches Engagement das
diese Ausstellung und den Katalog ermöglichte.

Finally, special thanks are due to the following
people for their continuing love and support:/
Schließlich möchte ich mich bei den folgende
Personen für ihre liebevolle Begleitung und
Unterstützung bedanken: Bia Gayotto,
William and Jean Lockhart, Kelly Nipper,
Annette Sievert, and Alex Slade.

Sharon Lockhart, Los Angeles, 1999